FAVOURITE FLOWERS

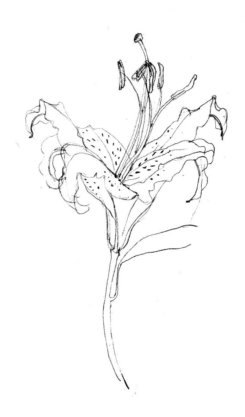

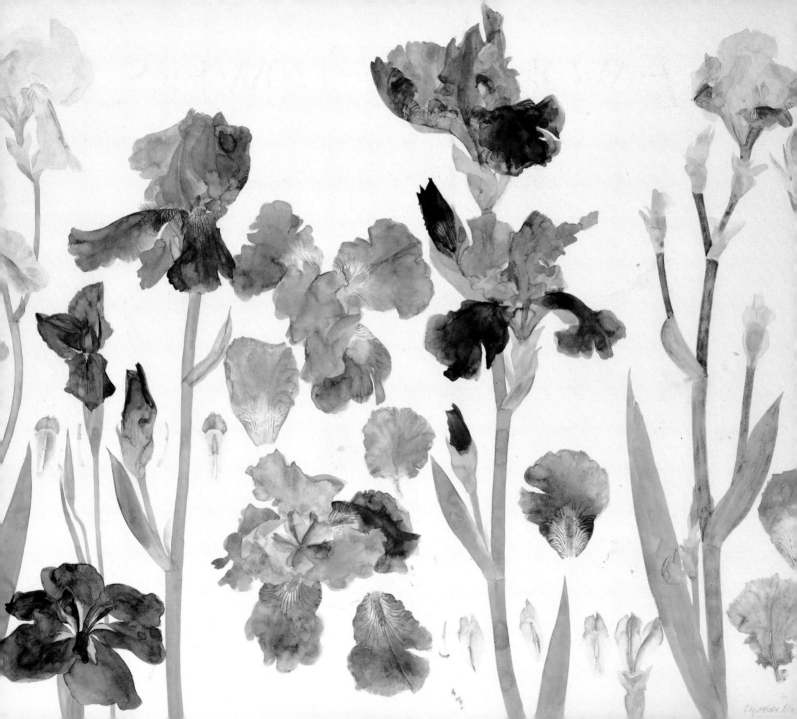

FAVOURITE FLOWERS

Watercolours by Elizabeth Blackadder
Commentary by Deborah Kellaway

PAVILION

TO JOHN

E.B

ELIZABETH BLACKADDER WOULD LIKE TO ACKNOWLEDGE THE HELP GIVEN TO HER
BY GILLIAN RAFFLES OF THE MERCURY GALLERY, LONDON

THIS EDITION PUBLISHED IN GREAT BRITAIN IN 1996 BY
PAVILION BOOKS LIMITED
LONDON HOUSE, GREAT EASTERN WHARF,
PARKGATE ROAD, LONDON SW11 4NQ

A CIP CATALOGUE RECORD FOR THIS BOOK IS AVAILABLE FROM THE BRITISH LIBRARY.

ISBN 1 85793 865 8

PRINTED AND BOUND IN SPAIN BY BOOKPRINT

2 4 6 8 10 9 7 5 3

THIS BOOK MAY BE ORDERED BY POST DIRECT FROM THE PUBLISHER.
PLEASE CONTACT THE MARKETING DEPARTMENT.
BUT TRY YOUR BOOKSHOP FIRST.

FRONTISPIECE: BLUE AND MAUVRE IRISES (DETAIL), 1988

Contents

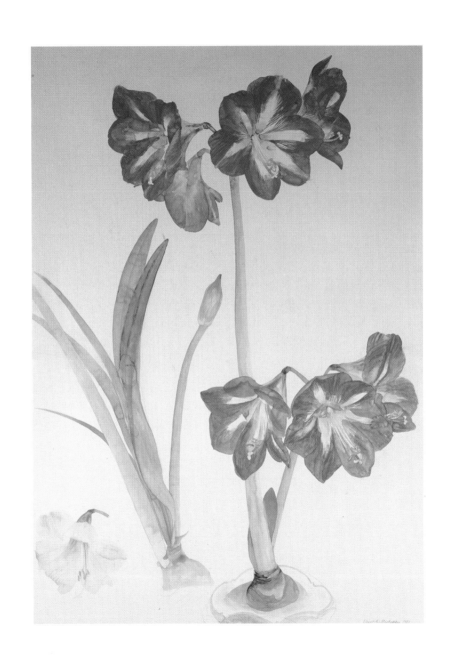

Publisher's Note

The illustrations in this book represent a body of work spanning fifteen years, from 1979, when Elizabeth Blackadder painted the first of her series of still-life paintings of flowers, *Amaryllis and Crown Imperial*, to her most recent work with wild flowers and banksia. Many of the paintings are reproduced in their entirety, but others, because of the format of the book, are not shown as whole compositions. Some plates illustrate a detail of a painting which, despite not showing the complete work, enables the individual flowers to be examined. The works reproduced in this book are in public and private collections in Great Britain and abroad.

Red Amaryllis, 1989

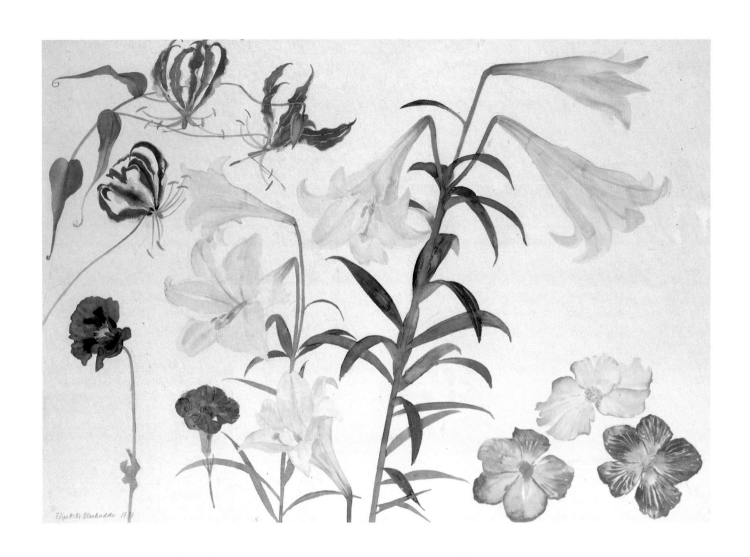

LILIES AND BEGONIAS, 1988

8

THE ARTIST AND THE FLOWERS

*A great botanical artist must have a passion for flowers . . .
unless he* loves *what he is drawing, unless he* knows *the
flower in all its moods, in all the stages of its development,
there will be something lacking in his work.*
WILFRED BLUNT, 1950

IT IS TRUE. All the great botanical artists have loved and known their flowers. But the converse is also true: the best way to know a flower is to paint it. Wandering round our gardens, admiring the borders, we do not scrutinize our flowers in close-up. We think we know them, we could immediately describe their height and colours. But if asked how many petals a tulip has, we might falter. And what about the petals of the lily? The fritillary? The amaryllis? The answer turns out to be the same in every case: six – or rather, two sets of three, one inside the other, corresponding to the sepals and petals of a conventional flower. Even the orchid, in all its diversity, can be reduced to this formula: three petals inside three sepals – though the third orchid petal plays wild variations on the theme.

Three is a satisfyingly simple number; twice three is more satisfactory still, making the odd, even; all these flowers have a shapely clarity which is what draws Elizabeth Blackadder to them. So does her favourite flower, the iris – that perfectly balanced shape where the three central petals stand up, and the three outer ones curve down. To be made aware of this floral geometry does not diminish our response to the flowers; it enhances it, and to discover that six of the flowers that attract Elizabeth Blackadder share the same underlying relationship, a structure based on two-times-three, is an added satisfaction.

Elizabeth Blackadder painted her first flower study in 1953 while she was still a student of Fine Arts at Edinburgh University and Edinburgh College of Art. It was in oils: *Flowers in a Black Jug.* For the next twenty years, she was preoccupied with landscape, buildings, figures and still-lifes. But in 1963 she and her husband, the painter John

Houston, moved to a house where her studio opened on to the garden and they both began to grow lilies in pots; in 1966 she made a detailed pen-and-ink sketch of two regale lilies, one in full bloom, the other nearly over. Then, in 1975, she and her husband moved to another Edinburgh house with a big, sunny garden, and flowers began to make a serious bid for her attention as a painter as well as a gardener. Snipped-off flowers appeared amongst the boxes, ribbons and toys of her table-top still-lifes. Soon, a whole still-life would be made out of three or four vases of flowers painted in watercolour. Watercolour became her preferred medium for flower painting, and irises, tulips and lilies her preferred flowers, for these were the flowers that were proliferating in the garden. She filled fat little sketchbooks in the process of looking at her flowers intently, getting to know their structure, understanding how they worked. At the same time, she studied the work of great botanical artists like Georg Ehret and Ferdinand and Francis Bauer and began to collect botanical illustrations. She painted her own first botanical study, *Amaryllis and Crown Imperial*, in 1979. Two years later she helped to found and taught, at Edinburgh College of Art, a course in botanical illustration in association with the Royal Botanic Garden, Edinburgh.

But it would be misleading to call Elizabeth Blackadder a botanical artist. Botanical artists work with a specific aim: it is to give information to botanists – or, in the case of the illustrations of early herbals, to help people identify a plant accurately and avoid making a mistake when they recommended a herbal cure. This is not to belittle them. The best of them were brilliantly gifted and knowledgeable and even courageous, some venturing their lives in the service of their art. When a plant-hunter voyaged abroad in the days before cameras, he would take with him a botanical draughtsman to record his findings. Ferdinand Bauer was away for five years with Captain Matthew Flinders and the Scottish botanist Robert Brown, and made over a thousand drawings of Australian plants, sitting in cramped quarters on board *The Investigator*, with, on one occasion, salt water pouring in and ruining his work. A few years earlier, Sydney Parkinson died of fever on board Captain Cook's *Endeavour* before he had finished his paintings.

A botanical study aims to show everything about its subject, and to get everything right; precise measurements of the plant are taken, details and dissections are supplied along the side or at the bottom of the page. Of course the artist places his specimen on his page with care, aiming at visual pleasure as well as scientific accuracy; but accuracy comes first. The finished product has something fixed and definitive about it, as if to say: this is it.

Blackadder's flower paintings seem rather to say: this is how it was on that particular day. She goes into the garden with its iris beds, its ponds and self-seeding poppies amongst herbaceous flowers; she picks a flower, brings it to her upstairs studio, puts it in water and waits to see if it looks ready to be painted. Sometimes it does not, it is too stiff, like a self-conscious sitter for a portrait. A day or two later it may have relaxed and she must work fast and catch it in this mood. She will paint it life-size, but she will not measure it; she will rely upon her eyes and set it down as it appears to her. If she is using a blank sheet of her heavy, handmade paper, she may place it near one edge and leave the rest of the paper empty until the right companions present themselves to complete the composition. This sort of art needs patience as well as speed; sometimes a picture may wait to be completed for a whole year, until the due season comes round again.

Elizabeth Blackadder is not impatient; she habitually has several paintings in progress at once; if she encounters a difficulty in one, she does not force it forward; she allows it to rest while she switches to another picture, perhaps even to another medium. She has one studio for watercolour, another for oil. She may be working on a portrait, a landscape and a still-life at the same time as the flowers. Unlike the Dutch flower-painters of the seventeenth century, she is reluctant to build up her finished paintings from earlier studies; she paints the flower directly on to the page with a swift, assured hand.

Superficially, the difference betweeen those Dutch flower-pieces and Elizabeth Blackadder's is absolute. The earlier compositions are *tours de force*: they use many of the Blackadder flowers – the iris, the tulip, the fritillary, the poppy, the anemone – glowing against dark backgrounds, rising in splendidly unified variety from a glass vase which

stands on a stone ledge, and arranged so as to show off each flower to its best advantage, and also to show off the artist's virtuosity; he adds shells, snails, fruits, birds' nests, lizards and insects in a *coup d'oeil*: so real, and yet, in the end, so unreal! The arrangement is too perfect to be true.

There seems, at first sight, no sense of arrangement about the flowers that stand in their assortment of glasses and jugs waiting to be painted on Blackadder's big studio table. Sometimes they appear almost perversely un-arranged, with the tall ones leaning out at the edges, the short ones in the middle. They are not crowded together, they have space to breathe; two different species never have to share the same vase. Sometimes the vase does not show in the painting at all; the flowers seem simply to be standing side by side. They exist against white backgrounds, removed from the distractions of the garden. It is the individual flower, in all its uniqueness, that matters.

And yet, at a deeper level, Elizabeth Blackadder and the old masters share the same concern: to turn the observed flowers into a strong, unified composition – a picture, existing within its own limits. And the apparent non-arrangement of Blackadder's flowers is seen to be not casual at all, but considered; if a long stem leans outwards, it is in order that its coloured flower may occupy a particular space. The vases may not be 'arranged'; the picture most certainly *is*, with exquisite, intuitive tact. And though Blackadder may leave one or two flowers waiting on the edge of her paper for months, she will have had from the beginning a general notion of how the space is to be filled – and, indeed, of where it is to be left unfilled.

What is she looking for? Flowers that excite her, of course, with their shapes, colours and textures. She fulfils Wilfred Blunt's requirement quoted at the head of this essay: she *loves* her flowers. Like Van Gogh with his sunflowers and Monet with his water-lilies, she is impelled to paint her irises, tulips, orchids, over and over again.

People have always wanted to paint flowers – because they are beautiful. Since the beginning of civilization they have been used decoratively in applied arts. There they are in the paintings of the T'ang dynasty and the Sung dynasty, and in the carved friezes of

the Taj Mahal, in Persian miniatures, along the margins of illuminated medieval manuscripts, and on seventeenth-century Japanese screens. Painters who have devoted most of their lives to a study of the human figure may still have had brief, intense encounters with flowers. When Stanley Spencer returned to England from abroad one spring and saw a magnolia in full bloom, he made a whole canvas out of one laden branch, white goblets in close-up against an April scene of grass and bare trees. In the last few months of Manet's life, he used all his rich experience of colour in a series of flower studies in oils: two or three flowers at a time (a radiant yellow tulip with strokes of tawny red, a purple clematis or a pink carnation) in a thin glass vase engraved with a dragon. They were the flowers that visiting friends had brought to him when his health was failing and he was closeted indoors.

But there is another reason for painting flowers which has nothing much to do with their intrinsic beauty, for it can lie behind the painting of a dying dandelion caught at its most forlorn, dank moment, after its petals have fallen and before it turns into a dandelion clock. Nearly five centuries ago, Dürer painted it thus in his famous *Das grosse Rasenstück:* a few feet of turf, a patch of weeds beside a little piece of water – burnet, saxifrage, yarrow, seeding grasses, and the dandelion. His angle of vision is so low that his humble subjects seem to grow in stature. The entirely unpretentious watercolour is deeply satisfying, and it is the painter's devoted accuracy that makes it so.

This is the starting-point for Elizabeth Blackadder's flower painting too. It is the joy of direct observation, the urge to tell the truth, and so to catch the essense of the flower. 'I don't take liberties,' she says. She means that she neither exaggerates nor idealizes. Her flowers, like Dürer's dandelion, are allowed to shed petals, to flop, even to die. And that is why they live.

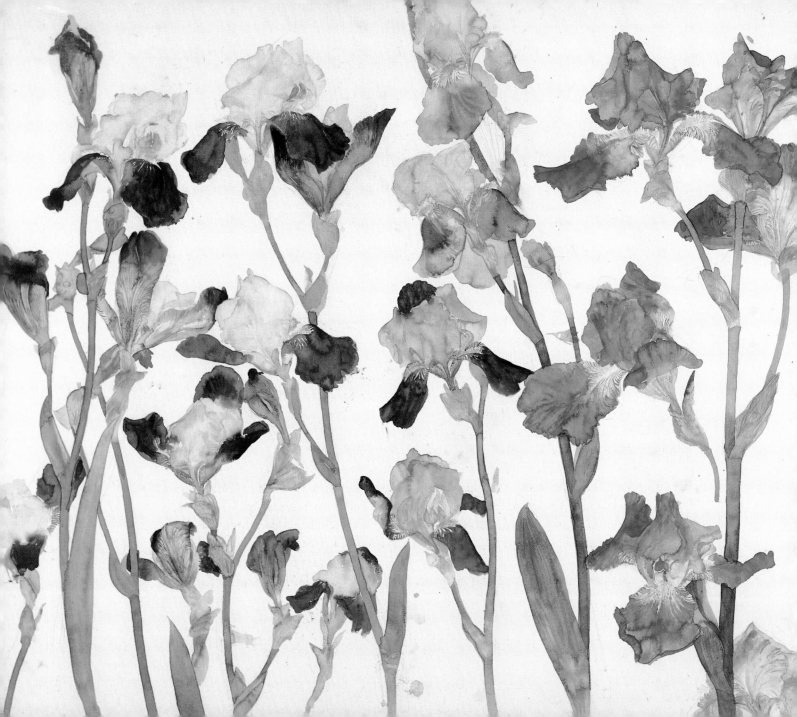

*I*RISES

Is there such a thing as an ugly Iris? Less pretty ones there
may be, but uglies – perish the thought! There are irises
for every soil and situation too – Spanish Irises and
English for sunny borders, and German Irises for
everywhere, even London, and Ochroleuca Irises for the
bog, and Cristata Irises for the rock bed and – and
Oncocyclus Irises for the Kingdom of Heaven!

REGINALD FARRER, 1919

ALL IRISES BELONG to the Kingdom of Heaven – not just Farrer's *Iris oncocyclus*. For the Ancient Greeks, the iris was the emblem of the Gods; for the Pharaohs of Ancient Egypt, a symbol of regality; in the Middle Ages, it became the flower of chivalry, 'a sword for its leaf, and a lily for its heart' (Ruskin). There was some confusion, in those days, as to whether the iris was a lily or not. Dutch and Italian old masters included it in paintings of Christ to show His royal descent, and some also used it in pictures of the Virgin Mary. In the fifteenth century Hugo van der Goes painted three irises in the corner of his *Adoration of the Magi*, two white, one midnight blue. It is a miracle of loving observation, but it is not about the irises: it is about the purity of the Virgin.

Four centuries later, Van Gogh painted them, contorted and even slightly crazed, in the garden of the asylum at Saint-Rémy. And in the early twentieth century Monet painted them where they grew in his garden at Giverny along a gravel path or beside the lily-pond. He returned to them often but here, too, the paintings are not primarily about irises; they are about colour and sunshine, and about blue dissolving into light or water.

Elizabeth Blackadder's iris paintings are *about* irises – everything about them, their colours, their textures, the quirky movements of their petals, the way they join the stem,

PURPLE IRISES (DETAIL), 1992

the whole of their brief lives from birth to death. She has painted them again and again, usually in watercolour, which seems to suit them best, for the iris petal itself looks as though it was washed with a watercolour paint brush. Since 1979 she has watched them opening in her garden and recorded each different variety in an iris sketchbook. It became her favourite flower.

What is it about the iris that has attracted painters since the beginning of civilization? It is, of course, the shape, the three petals that grow downwards (the 'falls') balancing the three petals that curve upwards (the 'standards'). When an iris is in bud, its six petals tightly furled as an umbrella, it is wrapped in a sheath of tissue-paper, as befits such precious beauty. The sheath gradually pulls away and the coloured tip of the outside petals can be seen. At this stage the falls are pointing upwards, enclosing the standards, but everyone who grows bearded irises must have noticed how soon the falls, freed from their sheath, begin to ripple and detach themselves, still folded but irresistibly drawn outwards, until at last they unfold and find their true shape (broad and rounded) and their true direction (down). Of course, as the falls take up their proper place, the standard petals are at liberty to take up theirs. Now the details of the lovely downward-tending petals are revealed: each one has a crest of upstanding bristles – a beard – along its midriff near its base, ending just before the petal narrows into a 'claw' or 'heft', the colour

Yellow and Purple Irises (detail), 1993

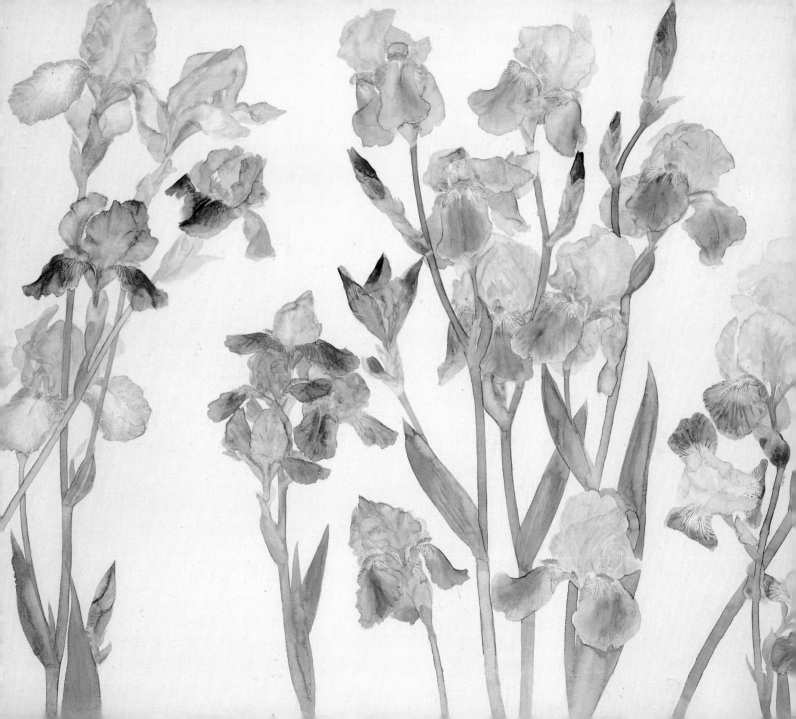

of the beard contrasting with the main colour of the petal, which seems to run in subtle veins from the edge of the petal to its base.

If you gently open the arching standards, you find that what they have been hiding is a final variation on the number three – a three-branched style. It looks almost like a flower itself, a flower within a flower; its three narrow, arched segments are ribbed down the middle, thick and lustrous and of a paler colour than the three fall petals above which it is poised. Below it, three stamens lie hidden, one coming from the base of each fall.

Bend over the flower, and you discover its strong but secret scent – not sweet and certainly not pure, but powerfully emotional, reminiscent of other irises smelt on other days. Colette described a bed of irises as a 'torpid pool':

> *Nervous women blanch there, pushing away with their hand the insupportably languorous perfume exhaled by all those heraldic tongues.*

Another haunting scent is that of the famous orris perfume, which is derived from the dried roots of *I. florentina*, the exquisite pure white iris which is the emblem of the city of Florence.

Bearded irises, their shapes and colours, obsess amateur hybridists as well as professionals, always hoping for a new colour-break, a perfect combination of standard and fall, and at least three branches to a stem and seven flowers to a branch. There has been an Iris Society in Britain since the 1920s, and in the USA for almost as long. Indeed, for the last three decades North America has been producing the finest bearded irises in

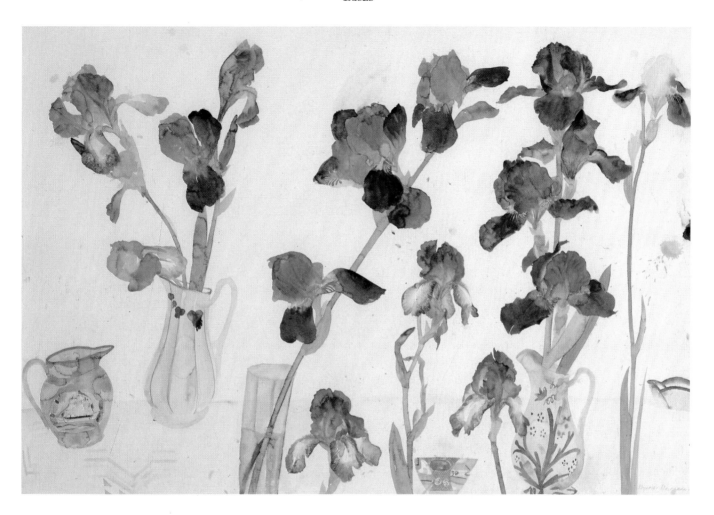

STILL LIFE WITH BROWN IRISES, 1988

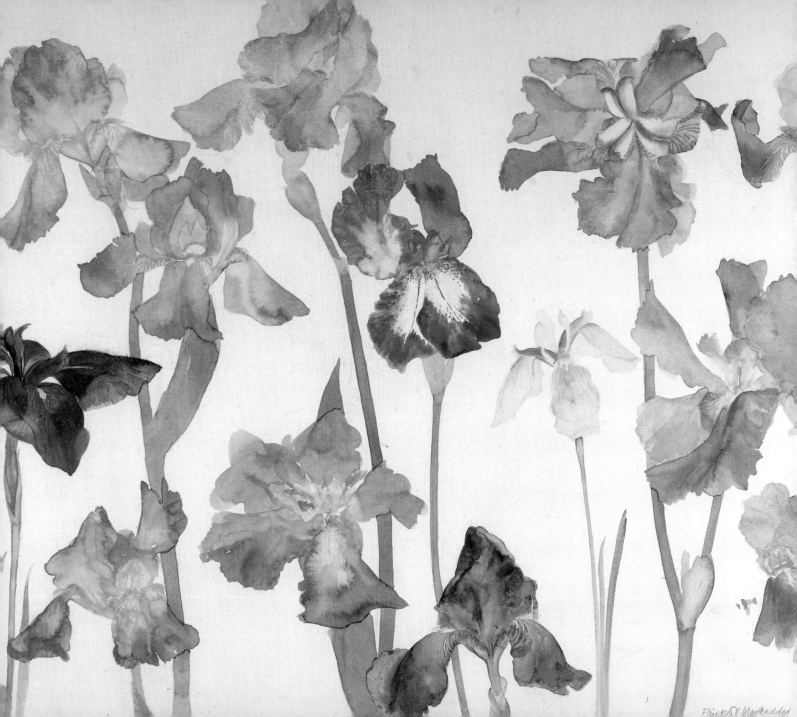

the world. The business of judging a new iris is as stringent as the judging of a dog at Cruft's Dog Show. The standards should curve outwards before they turn upwards; they must be broad enough to meet each other – gaps between them will not do. If the falls are flared, turning slightly upwards at the bottom edge, so much the better; they must certainly never reflex and touch the stem. They can be frilled or ruffled along the edges like a négligé or a dancer's skirt (indeed, the ruffles may help to protect them from wind and rain), but they must not be made of flimsy stuff, they must have 'substance' – velvet rather than chiffon.

As for colour – nothing is barred. The breeders still strive for true scarlet, true blue. Meanwhile gardeners can be thankful for the soft spectrum of rainbow colours: Iris, after all, was goddess of the rainbow. The standards and falls may be different colours, or different shades of the same colour, or they may be a uniform colour all through. They may be 'Plicatas', where light petals are etched or stippled with a deeper tint. (These, Elizabeth Blackadder says, are particularly hard to paint.) Sir Cedric Morris, gardener/flower-painter, was the first to hybridize a pink iris with a tangerine beard. Now the pink iris takes its place amongst the lilac and lavender and pearly-grey, the clear yellow, the heliotrope and the deep violet and indigo (you can guess these by cultivar names like 'Night Owl' or 'Sable') and finally what E.A. Bowles called 'thunderstorm bronzes and

BEARDED IRISES AND JAPANESE IRIS (DETAIL), 1993

lurid buffs'. Bowles was on intimate terms with the colours of his irises through trying to paint them. His favourite iris was *I. pallida dalmatica*:

> *a mingling of Rose-madder and Ultramarine blue, as I have learnt from painting it, and one must keep on squeezing one's tube of Rose-madder at a ruinous rate to give the warmth of the shades in hollows and on the sides of the falls.*

Irises mix together without a thought of clashing, unlike modern hybrid roses. They also behave amiably with other border flowers in all the freshness of early summer: lupins, columbines, old roses. But they look loveliest on their own, and that is how they exist, in perfect harmony – the pastel satins and the dark velvets side by side – in Elizabeth Blackadder's translucent watercolours.

Of course she grows, and paints, other sorts of iris too: the tall, graceful sibiricas, easy beauties to mark the corner of a border, where their slim, strong stems carry a spread of misty blue flowers in May and where their clumps of rushy leaves will look good all summer long. She grows the tiny, early reticulatas and uses them as precise details in still-lifes amongst Japanese fans and paint brushes and boxes – just as we gardeners use them as precise shapes of shining blue on the fringes of the winter garden. She grows the

Irises (detail), 1992

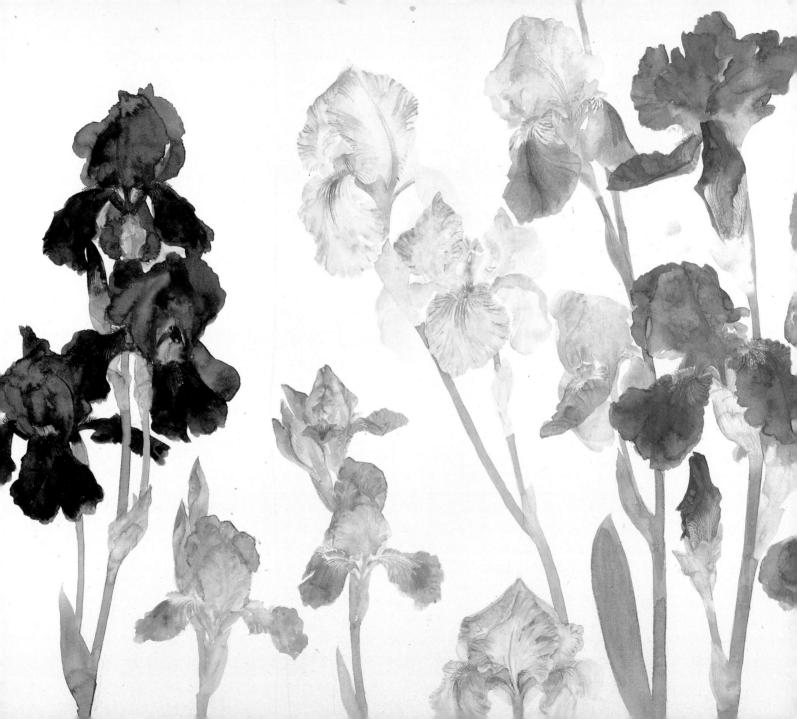

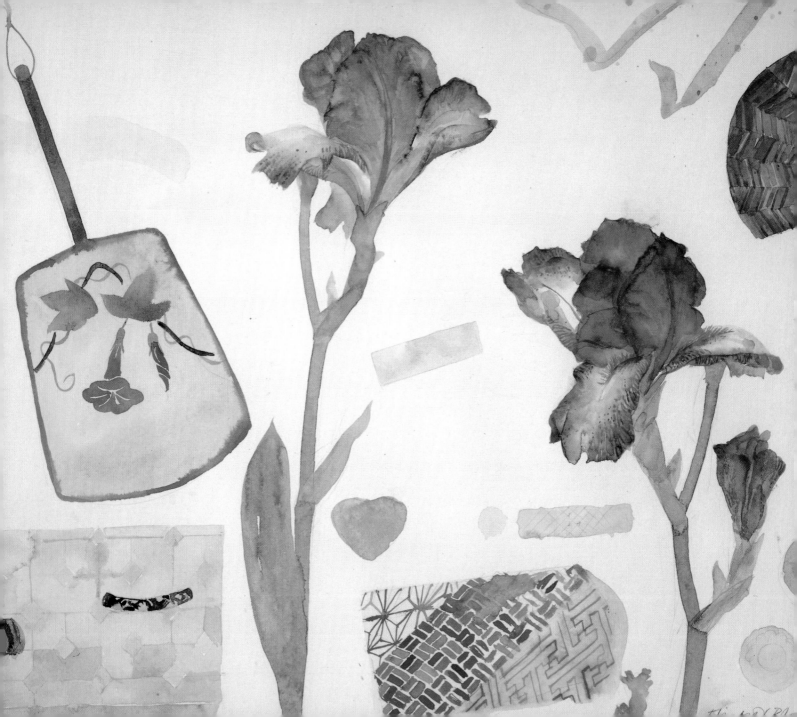

winter-flowering *I. unguicularis* with the long white style instead of a stem, which gave it its earlier name of *I. stylosa.* She grows the Japanese water iris, *I. kaempferi,* in the shallows of her garden pond; it opens to a great flat flower because its standards grow outwards and try to look like falls. And finally she grows the common flag, *I. pseudacorus,* the plant with the bright yellow flowers and leaves so long that they bend over three-quarters of the way up, like broken lances.

This was the iris, so legend goes, that guided Clovis I, King of the Franks, and his army across the Rhine when they were in retreat from the Goths. They saw where the irises grew far into the water, reasoned that the water must be shallow there, and forded the river. Later, when Clovis embraced Christianity, he adopted the iris as his emblem. He was on to a good thing: by the twelfth century, his flower had become the fleur-de-lys, flower of Louis VII or, in England, flower-de-luce. There it was, its fluid shape stylized and simplified, its three standards reduced to one, its falls to two, a minimalist iris fixed eternally in gold leaf or gold thread – or carved in oak on parish pew-ends: the Flower of Kings.

STILL-LIFE WITH FANS AND IRIS (DETAIL), 1988

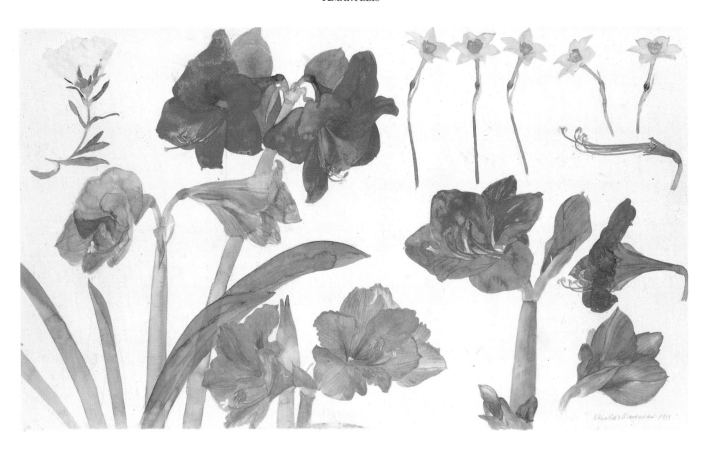

AMARYLLIS, NARCISSUS AND HIBISCUS, 1988

AMARYLLIS

Was it not better done, as others use,
To sport with Amaryllis in the shade . . .?
JOHN MILTON, 1637

AMARYLLIS is such a beautiful name that Milton used it to add music to his *Lycidas*. A hundred years later, Linnaeus added further music by giving it the second, specific name of *belladonna* – 'beautiful lady'. He did this, he said, because of the 'exquisite blending of pink and white in that flower, as in the female complexion'.

But 'that flower', the half-hardy *Amaryllis belladonna* which arrived in Britain from South Africa in 1712, is not the flower we still call the 'amaryllis' today – the one that Elizabeth Blackadder paints. The current name of this flower is the rather less appealing *Hippeastrum*. It is clearly related to the belladonna lily, *Amaryllis belladonna* (they each have umbels of funnel-shaped flowers on tall stems, and leaves that follow later), but it comes from South America and the botanists have decided to class it separately. So now, as we admire our breathtaking potted amaryllis flowers in our heated rooms in winter, we must practise saying: 'hippeastrum'.

The hippeastrum, then, can indeed have a beautiful complexion of pink and white, but it can also be pure white, or salmon, or orange, or dusky crimson, or thrilling blood red, or it can be striped, or scarlet with a white star in the centre. Every time you peep at the slit of the growing point in a newly planted bulb, nothing seems to be happening. Then, one day, you fancy you can perceive a pale green blade edging above the split. From now on, all is miracle. You move it into your sitting room and watch it grow.

Its flower-stem is improbably fat, and if there is inadequate light, it may grow perilously tall (you should sport with your amaryllis in the sun, rather than the shade). At the top of the stem, the flowers are packed in a pale green spathe, the green deepening a

little towards the point. The whole bud is the shape of an enormous teardrop, pointed at the top, rounded at the base. When the spathe wrinkles back, a collection of four or five or even six small flower-buds is revealed, one or two of them *very* small, which conveniently means that the flowers will not all open at once: there will be a staggered display. Curious thread-like tendrils curl between them. The big buds slowly move away from the vertical to take up their places at right-angles to the stem. The day comes when the first two buds have assumed expectant, bulbous shapes. For a whole day the petals are unfurling, and when you come back into the room the next morning – two enormous trumpets are open: you can look down their throats.

It is partly the size of the hippeastrum that takes the breath away – size mixed with height and almost unreal symmetry, as if, after all, perfection could be reached. Its flower structure can be simply described in terms of a clock-face: the three outer petals are mathematically placed at twelve o'clock, twenty-past and twenty-to the hour; the three inner petals fill the spaces – ten-past, half-past, ten-to: the circle is complete. In the middle, the six stamens dangle like the weights of a long-case clock, biscuit-coloured anthers on white filaments, with a frail white pistil longest of all. It is said that you can prolong the flower's blooming by pulling off its stamens; the suggestion seems faintly shocking. Besides, if you are lucky, a second stem will be rising from the bulb, preparing to take over.

The hippeastrum can look stolid, lumpish in paint, but in Elizabeth Blackadder's watercolours its flaunting vitality is half-transparent.

AMARYLLIS AND ORCHID (DETAIL), 1982

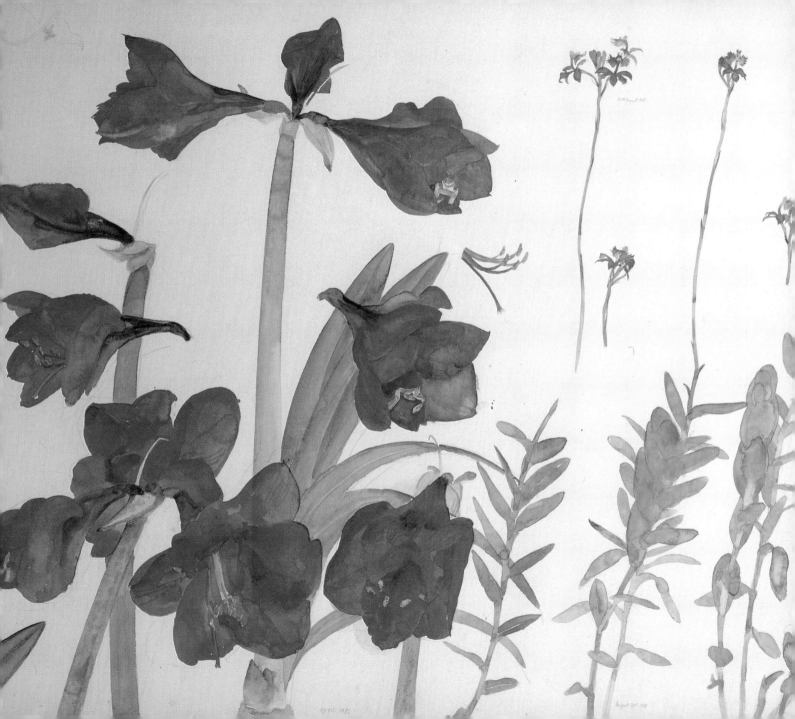

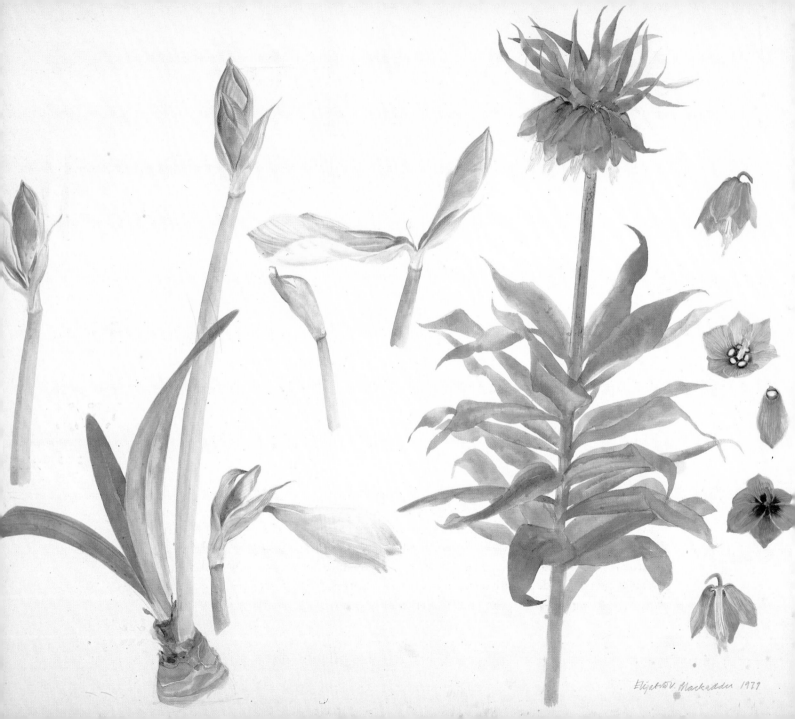

Elizabeth V. Blackadder 1979

FRITILLARIES

*The Crown Imperial for his stately beautifulnesss deserveth
the first place in this our Garden of delight to be here
entreated of before all other Lillies . . .*
JOHN PARKINSON, 1629

IN ELIZABETH BLACKADDER's first botanical study, *Amaryllis and Crown Imperial*, 1979, the crown imperial is lording it over the amaryllis, fully open while the amaryllis is still in bud. Though you can't see its full height, you can guess its majestic stature from its erect posture and the strength of its stem. A strange, upside-down crown it is with an unruly top-knot of green bracts like a pineapple's, and below this a circlet of downward-facing flowers, yellow or orange or brick red or bronze; six ivory-pale stamens dangle from each bell, but the jewels are hidden from view. If you lift one flower to look inside, you see six glistening drops of nectar, one at the base of each petal. Gerard likened them to 'faire orient pearles'. Blackadder has tilted a specimen flower at the side of her picture to show them off. You would think such nectar would be accompanied by a ravishing perfume, but a quirk of nature has made the whole plant (particularly its bulb, if you strike it with a spade) give out a strong scent of fox mixed, according to some noses, with garlic.

When the crown imperial arrived in Europe from Iran in the sixteenth century, hot on the heels of the tulip, the two genera were recognized as kinsmen. The fritillary's flowers are like the tulip's upside-down; accordingly in conventional seventeenth-century Dutch gardens, tulips and crown imperials were lined up together in box-edged parterres punctuated by gilded statues and tubbed trees. Botanical illustrators set to work to

AMARYLLIS AND CROWN IMPERIAL, 1979

display the crown imperial's 'stately beautifulness'. One of them, P. van Kouwenhoorn, responded with excitement to the twisting movements of the top-knot bracts and the leaves on the stem; in his study, the flower took second place to the leaves, which he showed crisp-edged, twirling like flames. If a still-life artist included a crown imperial in his mixed bouquet, he placed it at the apex – there was nowhere else for such a large and forceful presence to go, though the little snakeshead fritillary (*Fritillaria meleagris*) can sometimes be seen modestly hanging its head much lower down the picture at the side.

Elizabeth Blackadder grows, and paints, *Fritillaria meleagris* too. *Frittilus* is Latin for 'dice-box'; *meleagris* is Greek for 'guinea-hen'; this little fritillary, which grows wild in English water-meadows, is chequered with purple over pale pink or white, and the checks have such mathematical precision and serial patterning they might be a miniature detail from a Bridget Riley painting. The cut of its six petals is neatly angled; not surprisingly, when artists first tried to paint it, it came out looking stiff and pleated, rather like a bit of origami. But as Blackadder's watercolour shows, it is not only neat but exquisitely graceful, its two delicate flowers balancing each other at the top of a wiry stem, and the exuberant top-knot of its imperial relative reduced to a single, slender, grey-green bract.

There are many species of fritillary; they come in chocolate brown or livid green or almost black. Elizabeth Blackadder grows *F. persica*, whose flowers, arranged in a tapering raceme at the top of a 20cm/8 in stem, have a dull, pigeon-coloured bloom on the outside of the petals, and a deeper plum-purple within. Such a colour scheme got low marks in the seventeenth century; it was dismissed as 'sombre', 'dull' and 'heavy', only to be tolerated as a foil for brighter things. When Redouté painted it for *Les Liliacées*, he made it smoke-blue, with glimpses of yellow stamens inside the flower bells. Today, nothing could be more sought-after than the dusky and temperamental *F. persica*, while *F. imperialis*, the crown imperial, is seen as a dear but unsubtle cottage-garden flower.

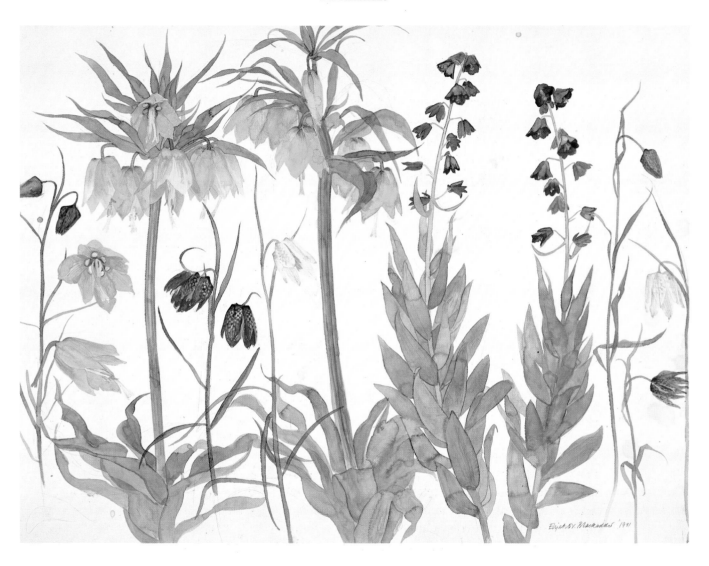

FRITILLARIA IMPERIALIS, PERSICA AND MELEAGRIS, 1991

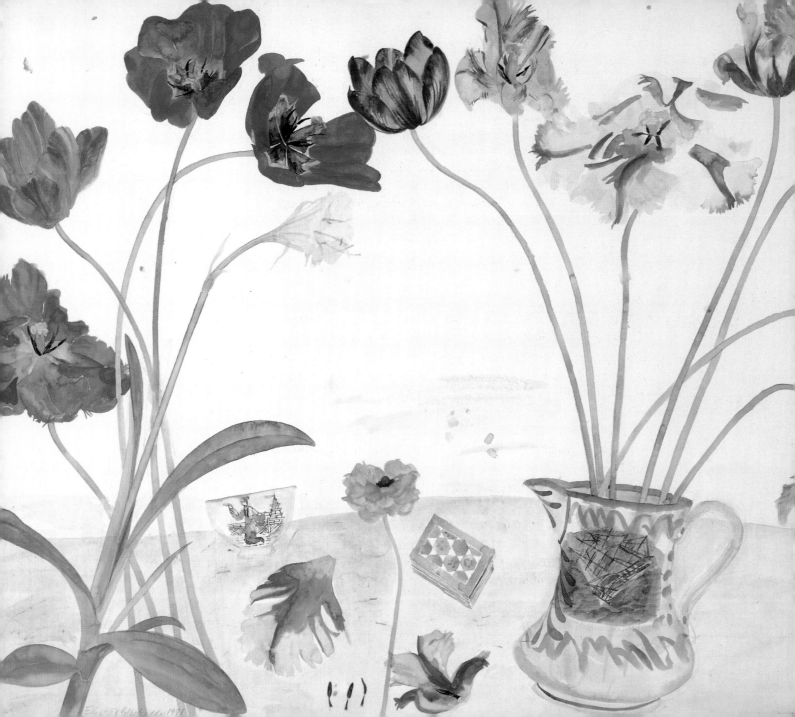

TULIPS

It was in Venice, years ago, that first I fell in love with Tulips such as these. On the marble altars of one of the great Jesuit churches were vases filled with Parrot Tulips, all cut-edged and gold and scarlet-splashed. It is a strange, disorderly beauty, and sometimes draggles and hangs its untidy head like a bell-flower, and sometimes flaunts it up full in the sun's face.
E. V. BOYLE, 1884

THIS IS THE BEAUTY of Elizabeth Blackadder's tulips: strange and disorderly. They include the Lily-flowered, the Fringed, the Triumph and the Parrot, aptly named classes, for some have pointed, reflexed petals like a lily's, some are frilled and fringed and lacerated, some are clamorous and gaudily streaked, all have a wild, triumphant air. They are the opposite of the neat tulips with the tall, straight stalks and the large, cupped flowers – Darwin tulips, named after the scientist in 1889 – which line up regimentally in our public parks in spring. But Elizabeth Blackadder grows these too. The grandly austere black tulip, 'Queen of the Night', takes its place amongst the others in her paintings.

In essence, all tulips are satisfyingly simple flowers. They have six petals (or, if you like, three petals and three sepals of the same colour) and inside the cup there are six stamens, one for each petal, and a triangular ovary in the centre, made up of three cells. As a tulip flower matures, its petals fall outwards – even the Darwin relinquishes its neat shape as it ages – and you can see the dark anthers poised endwise on the pale filaments of the stamens, and the important and leathery capsule in the middle. The gardener feels sad

TULIPS IN A SUNDERLAND JUG (DETAIL), 1988

35

when the whole flower loses its coherence and the petals loosen, one by one, and instead of a cup or claret glass there is a flat wheel, but Elizabeth Blackadder catches the moment, paints the process, shows that there is still beauty in the overblown flower-shape, reveals the heart of the flower and makes fallen petals complete the picture.

When you pick a tulip and put it in a vase, however disciplined it was in the garden, it will not stand up straight for long. Soon, its stem will begin to curve and swoop and make ogee patterns in the air. A vase of tulips rearranges itself; the blooms swing away from each other; if one chooses to grow upwards, its neighbour will avoid it and bend downwards; a new symmetry will emerge, more painterly than the battalions of parallel stems in formal tulip beds, and Blackadder will allow it to decide on its own pose and will await the moment when it is ready to be painted. Never will her jugs and glasses and carafes of tulips look less than natural.

This sort of flower painting seems, on the surface, the antithesis of the great Dutch flower-pieces of the seventeenth century, where it is clear that an overruling hand has been at work arranging the bouquet down to its smallest leaf. But even here, the tulips are not straight. The old masters exploited the looping stems, using them to give rhythm and direction to the composition. Sometimes one fluid stem will lead the eye up across the central axis to a perfect bloom at the top right-hand corner of the canvas, while a

Fallen Tulips, 1982

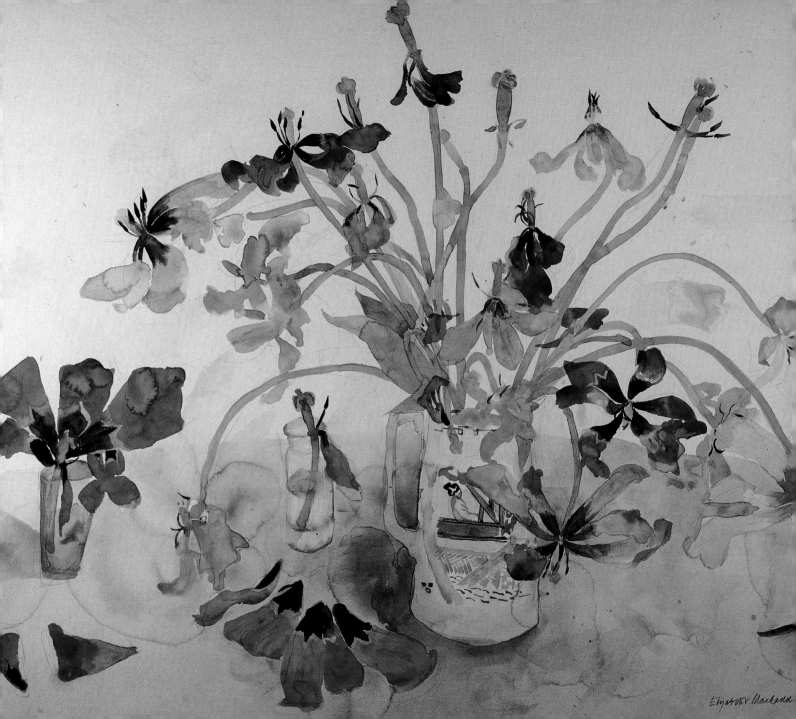

Elizabeth Blackadd

complementary but smaller tulip arches out halfway down the left-hand side and a final, exhausted flower capsizes over the rim of the vase at the bottom right. They will all be different colours and all, like Elizabeth Blackadder's, at different stages of their lives.

Tulips are a dominant feature in Dutch still-lifes, every streak on their petals lovingly reproduced. When Rembrandt painted his wife Saskia as 'Flora', he gave her a tulip dangling over one ear. The nurserymen of the day commissioned painters to illustrate large 'Tulip Books' as catalogues, from which customers could choose when tulips were not in flower. The tulip dominated the whole flower-crazy nation in the first half of the seventeenth century, and its streaks were the most important thing about it, more important than its shape. The story of these streaks is now history.

A bulb might have a deep, clear-coloured flower only changing to yellow or white at the base of its petals where they touched the stamens. But then, after six years or so, something strange might happen. The base colour would spread over the whole flower, seeming to push the old colour away into little rivulets along the petal fringes. The process was called 'breaking'; the pattern was called 'feathering' – a delicate tracery of red on white, or orange on yellow, round the edges of the flower. If a bold backbone of colour ran up the centre of the petal as well, flickering out at the top to join the feathering along the edges, this was called 'flaming'. These feathers and flames tended to be darker than they were originally, when they covered the whole flower: pink became scarlet, violet became inky black. The colour combinations had names too. Pink or cerise markings on a white ground were called 'Roses', violet or purple on white were 'Bijbloemen', and

brown, red or purple on yellow were called 'Bizarres'. Many of the loveliest tulips in the Dutch still-lifes are of 'Bijbloemen' – flowers whose pearly white petals are spread with a satin sheen, flamed or feathered in dark mulberry.

To maintain these patterns and create new ones became an obsession with the 'florists' of the day. Fantastic methods were proposed for encouraging tulip bulbs to break: they should be dipped in ink, or verdigris, or azure. (It was not known until much later that the 'breaking' of a tulip was caused by a virus and spread by aphids.) Even in nineteenth-century Britain, the 'artisan' florists of the industrial Midlands who showed their proud blooms at innumerable tulip shows were obsessed, above all, with 'broken' tulips.

Today, tulip breeders are more concerned to *prevent* breaking than to encourage it. You can buy so-called 'Rembrandt' tulips, in yellow striped with red, or white with pink, but they are poor, pale things beside the intricate glories of the past. Once, Elizabeth Blackadder grew and painted a streaked tulip in rich mahogany and yellow, but it has disappeared from the garden (in the way of tulips) and is not to be found in any modern catalogue.

The tulip came to Europe from the Middle East in the late sixteenth century and was an instant hit. John Parkinson thought it worthy of paradise; it is there, on the title page of his *Paradisus Terrestris*; Adam and Eve are standing beside it. Thomas Johnson, who republished Gerard's *Herbal* in 1633, believed it was the original 'Lily of the Field'. After the tulip's sensational career in Holland in the seventeenth century, including the three years of 'tulipomania' (1634–7), when bulbs changed hands for preposterous sums, the

fever spread back to Turkey and in the eighteenth century there was a milder outbreak of tulipomania there, with some of the new, streaked Dutch tulips joining the elegant lily-flowered, lyre-shaped species, which for centuries had been the most favoured in the East.

Accounts of tulip fêtes at the Turkish court are dazzling: theatrical displays of colour, illumination, bird-song, perfume and musical instruments. Beside every fourth tulip and level with it, a candle flickered in a jar. Caged birds were suspended all along the rows; behind the tulips, trellises were woven with jasmine and roses and hung with lamps; a consort of Turkish instruments played; and if any tulip dared to die, a reinforcement was rushed up in a glass jar. The sultan and his entourage stayed until the season was over. Of course, the tulip was equal to its starring role – especially when it was multiplied by tens of thousands.

How seductive it sounds – how paltry, in comparison, our treatment of tulips today! Nowadays some people favour treating tulips as wild flowers, putting them out to grass to take their chance after the naturalized daffodils and before the hay is cut. This is, at least, a solution to the question of where to plant tulip bulbs when they have done their time in ornamental flower-pots, or their three years in clumps on the border's edge, or their one year in conventional bedding schemes.

'How very much more charming different-coloured tulips are together than tulips in one colour by itself,' wrote Elizabeth von Arnim in 1899. Yet Russell Page, in his classic *The Education of a Gardener*, recommended a whole bed of black-purple tulips mixed

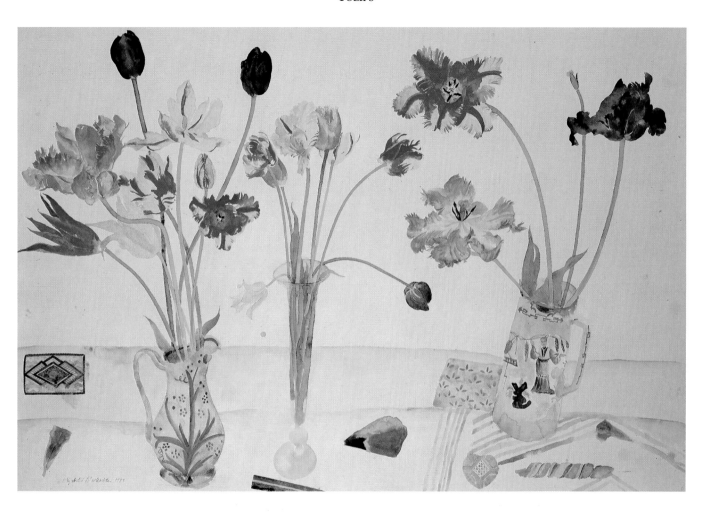

TULIPS, 1983

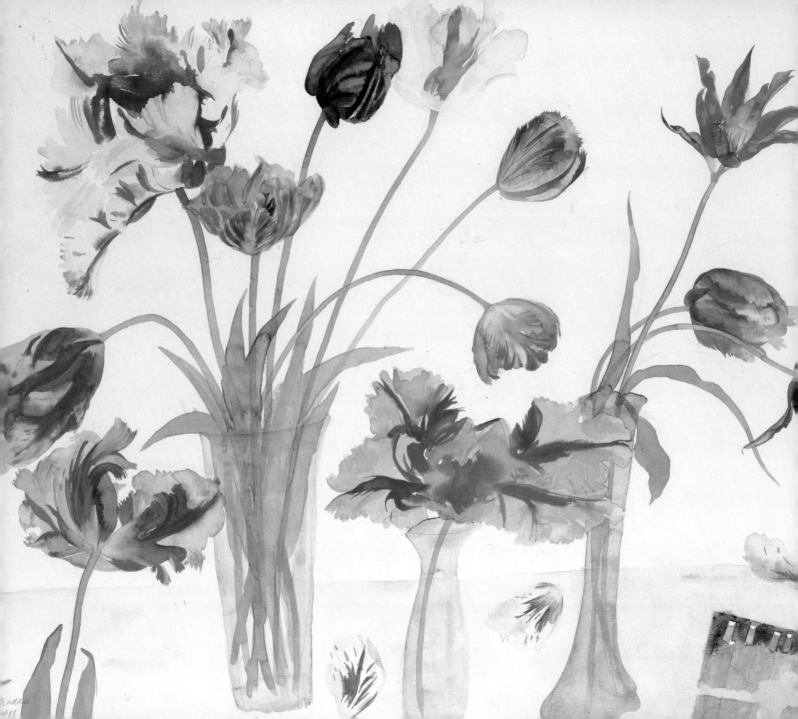

with white ones, and underplanted with white violas or deep blue forget-me-nots. E.A. Bowles arranged his tulips in a patterned parterre, with three kinds of orange in a round bed, 'dazzling rose scarlet' next door, then a bed of 'Clara Butt' in 'lovely soft warm pink'. Christopher Lloyd likes to plant his elegant lily-flowered and flaring parrots and 'square-shouldered' Darwin tulips among the solid green foliage of sweet williams, whose flowers open just as the tulip flowers are fading and comfortably hide the tulip leaves' gradual decay.

The tulip is what you make it, and how you see it. It is still the flower, above all others, that lends itself to the discipline of artificial pattern, but it is also a lovely emblem of the exuberant and free.

THREE VASES OF TULIPS, 1988

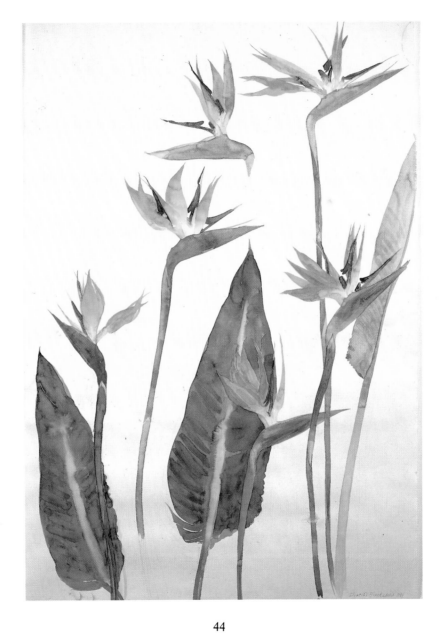

STRELITZIA

*There were quite a lot of birds in my room by now, as well
as flowers, for* Strelitzia reginae *had arrived, escorted by the
little African sun-birds which perch and powder their breast-
feathers with its pollen . . .* Strelitzia reginae *itself looked
like a bird, a wild, crested, pointed bird, floating on an
orange boat under spiky sails of blue and orange.*

VITA SACKVILLE-WEST, 1952

THE BOAT is not, in fact, orange – it is green, edged with pink and occasionally brushed
with purple. But then Vita Sackville-West was describing not reality, but a dream
that she had one wet March evening. Strelitzias belong to the realm of dreams, alarming
and improbable; the first time you see one, you doubt the evidence of your eyes. The bud
(which becomes the 'boat') is a long, sharp shape set at right-angles to the stem, green,
but touched with pink where it turns the corner. Presently, a flower emerges from a crack
along the top: long, silky sepals come first 'd'une belle jaune', as Redouté described them,
but we would call them a true and intense orange. There are three of them, but they take
some time to assume their final positions, with two standing upright and one lying down,
parallel with the bud which is now seen to be a boat-shaped protective spathe. Inside
these glowing sepals three petals of cerulean blue are lurking, two joined together and
protecting the anthers; the third, smaller, a nectary holding sweet liquor and hiding the
ovary. When this flower has arranged its plumage and is all ready for the long-tailed
sugar-bird or the little sun-bird to hover and perch on it, drink the nectar and receive its
powdering of pollen, a second flower makes its way up out of the crack in the spathe,
pushing the first one along a bit; then come a third, a fourth (there may be six altogether)

STRELITZIA, 1989

and soon the first flower is leaning backwards, the next one is erect, the third leaning forwards: a cockade has been made, a crest like an ambitious punk haircut, or like the top-knot of a crested crane.

So some people call it the 'crane flower'; others, 'the bird of paradise flower'. And others again, who know why it is named *Strelitzia reginae*, call it 'the queen flower'. When it first flowered at Kew Gardens early in the nineteenth century, Joseph Banks was so excited that he felt it could only be called after the Queen, wife of George III, Charlotte of Mecklenburg-Strelitz. At once it was a sensation. The *Botanical Magazine*, pledged 'to illustrate and describe the most ornamental FOREIGN PLANTS', departed from normal practice and pictured it on a specially large plate which had to be folded to fit into the covers. The Empress Josephine imported it for her garden and required Redouté to paint it; he showed it naturally nestling amongst the great ribbed paddles of its leaves (for it is a member of the banana family, the Musaceae). Then Reinagle painted it for Thornton's *Temple of Flora*, showing its imperious profile against a distant, imagined background of the rolling veldt, so that readers could know that its home is South Africa, where it grows along river banks or in clearings in the bush.

It seems cruel to stick a strelitzia in a vase – it leans wildly sideways like a bird caught by the leg and trying to fly away. Nor does it enjoy finding itself captive and for sale in a

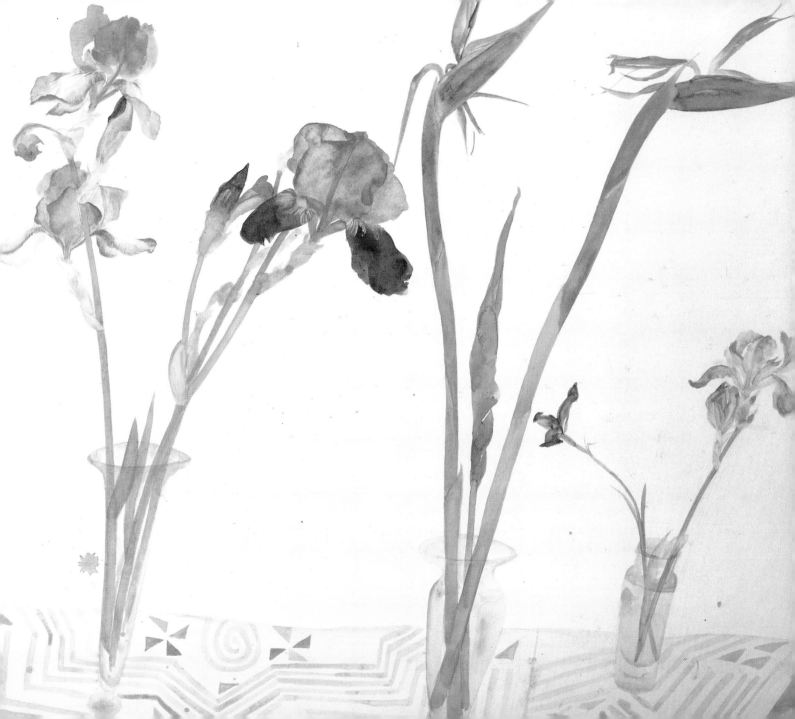

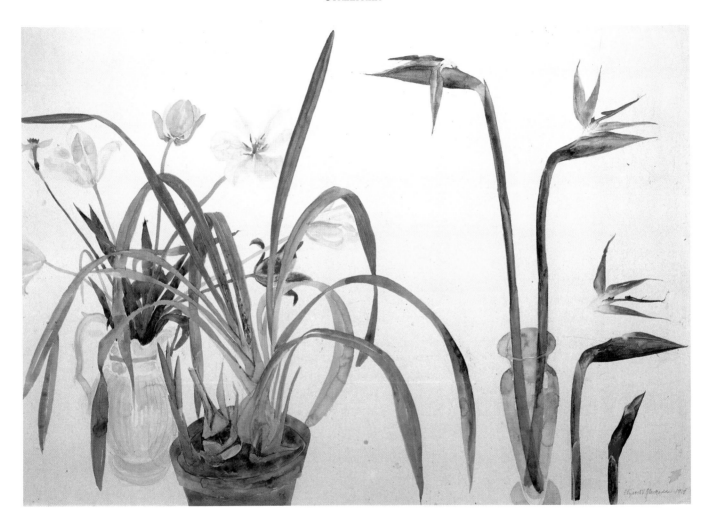

ORCHIDS AND STRELITZIA, 1979

florists' shop, partnered perhaps by wine-red carnations. But it has found itself unexpectedly at home in Elizabeth Blackadder's watercolours. Sometimes, it appears like a proud and provocative and occasionally dishevelled intruder beside a familiar, gentle iris or lily, curiously at ease and ready to have a dialogue provided that it is allowed to dominate the conversation and does not have to share a vase. Best of all, however, it enjoys a picture to itself, its only companion its own thick, shining, drought-resistant leaves.

Strelitzias are strong and so long-lived that they can become like respected elder members of a family. A noted nurseryman who cherishes one his grandfather grew (it is thus a veteran of two world wars) divides it with a bow saw from time to time. He pats it as he passes and refers to it as 'he'. And indeed, *Strelitzia reginae* is more like a fierce warrior than a soft, German-born queen.

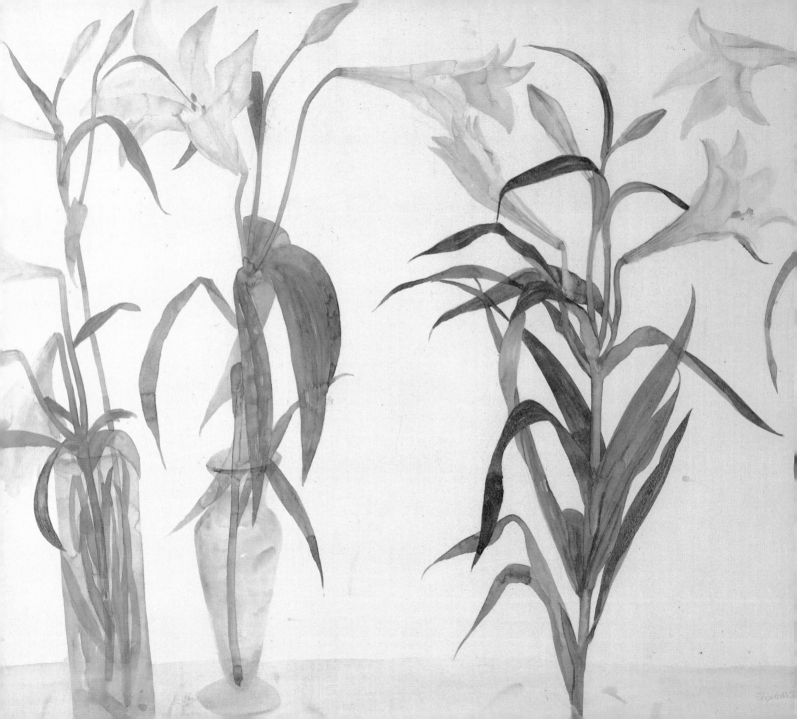

LILIES

Have you seen but a bright lily grow,
Before rude hands have touch'd it?
Have you mark'd but the fall o' the snow
Before the soil hath smutch'd it?
BEN JONSON, 1616

IT CAN BE SHAPED like a trumpet, a funnel, a star, a Turk's cap; it can dangle, or face out towards you, or up towards the sky; it can be lemon yellow, or orange, or pink, or vermilion, spotted or striped or plain. But at its quintessential loveliest, it is white.

Pure whiteness is the quality that Shakespeare, Spenser and Ben Jonson assumed when they used the word 'lily' in their verse. They were thinking of *Lilium candidum*, the only lily to be grown in Britain until the late sixteenth century: the lily that takes its place, traditionally, in a vase somewhere between the Virgin Mary and the Archangel Gabriel in medieval and Renaissance pictures of the Annunciation; it symbolizes purity – sometimes the Archangel brings it to Mary in his hand.

Its stem is tall, stiff, straight, often leaning away from the vertical; its leaves are scattered all the way up its stem; its flowers come in a raceme, the bottom ones opening first to release their overpoweringly sweet scent, the topmost buds pointing quite stiffly upwards, like fingers in white gloves. It was the subject of Leonardo da Vinci's first botanical study; he made a strong, muscular working drawing of it, as part of his scientific investigation into the mysteries of botany. Virgil named it 'candidum'; the Victorians called it the 'Madonna lily'; before that it was simply known, in English, as 'the white lily'.

Nowadays, it dies out in many gardens. If Elizabeth Blackadder wants to paint a white lily, she has at least four other beauties to choose from, grown by her husband in pots that

LILIES, GREEN AND WHITE (DETAIL), 1988

can be moved under cover when the weather is cold. First, there is *L. longiflorum* 'Gelria', the tender Easter lily, which has such purity of shape (single, slender funnels) and coolness of colour (white glimpsed through a veil of green) that it makes *L. candidum*, with its waxy texture and golden stamens, seem positively voluptuous. Second, there is *L. auratum*, the dazzling golden-rayed lily of Japan, its frilled and fragrant white flowers open wide to a star-shape, each segment striped down the centre with gold and spotted with gold or crimson. Third, there is *L. regale* 'Album', glistening pearly white all over, unlike its famous relative which is shaded deep rose at the back. And finally, there is a modern hybrid called 'Casa Blanca', with orange-brown stamens inside huge, bowl-shaped, pure white flowers.

These four lilies can be used as signposts along the road the lily has taken in the last two hundred years. *Lilium longiflorum* first came to England in 1819; it was part of the great waves of lilies from China and Japan that rolled into Europe throughout the nineteenth century. It belongs to warm, sub-tropical islands south of Japan and was sent to the London Horticultural Society's conservatory; the following year it produced one flower. (Nowadays it is grown in Bermuda, Holland and Belgium and produces its flowers in millions to supply the florists' trade, for not only is it supremely shapely but its tapering, slightly upward-tilted buds and polished leaves pack well.)

LILIES, TIGER AND AURATUM (DETAIL), 1991

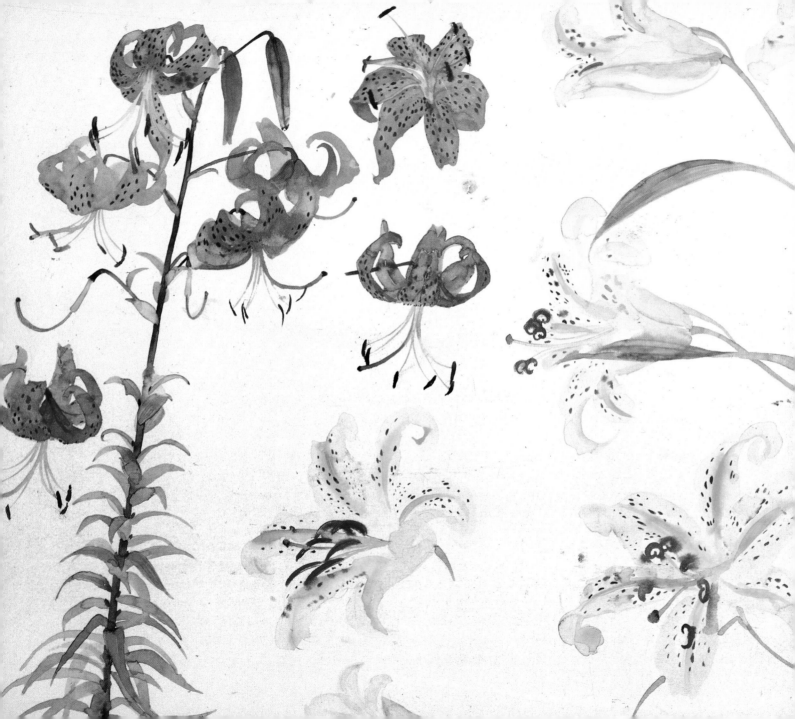

In 1862 *L. auratum* arrived. Various nineteenth-century travellers had already seen it growing in volcanic soil on the slopes of Mount Fujiyama, where it was cultivated as a food crop. Lily bulbs have scales which can be peeled off one by one and eaten in the same way as a globe artichoke's. But in England this tall, golden-rayed lily was regarded as a feast for the eyes, and the Japanese wisely began to export it in shiploads. In response to demand they overfed the bulbs, and gradually the imports became fat and soft, a prey to lily virus. People who had been wild to grow *L. auratum* in their gardens now suffered the disappointment of watching it sicken, and presently the idea took hold that all lilies are too difficult to grow.

Then, in 1903, came *L. regale*. The intrepid plant-hunter E.H. Wilson found it growing along the precipitous, narrow Min valley in Western China. Here was this intensely sophisticated, ravishingly perfumed trumpet with petals made out of some thick, sumptuous material, frosted white on the inside, ribbed in rosy wine on the outside, with a pollen yellow throat, rising out of rock crevices amongst coarse scrub. 'Rude hands' had certainly never touched it. It was growing, wrote Wilson: 'not in twos and threes but in hundreds, in thousands, aye, in tens of thousands.' He sent some home to Veitch's nursery; they proved strong and reliable. Wilson was posted back to China to collect lots more bulbs. On this journey, having safely secured his lilies, he slipped on the granite slopes in a landslide and broke his leg so badly that for the rest of his life he spoke of his 'lily limp'. But he knew that it had been worth it. *L. regale*'s health was the answer to *L. auratum*'s frailties; anybody could grow it in any garden. Quantities of it reached America

at about the same time as England and on both sides of the Atlantic the serious love affair with lilies was under way.

It had been gathering strength, of course, throughout the nineteenth century, and in 1877 one of the most sumptuous botanical folios ever produced was brought out by the wealthy landowner and lily fancier, J.E. Elwes: *Monograph of the Genus Lilium*, with hand-painted lithographs by the leading botanical illustrator of the day, W.H. Fitch. It went into several supplements over the next few decades, as more and more lilies were discovered – or created. For the hybridists were at work – in Scotland, New Zealand and America – above all at the Oregon Bulb Farms, under the skilled control of Jan de Graaff. And this is where the fourth white lily, the brand new 'Casa Blanca', belongs, a representative of the multitudes of hybrid lilies which now fill the catalogues, the flower shows and people's gardens.

They are not usually white, of course. They are more likely to be fierce orange, or bright red, or hectic pink. Some of them draw on the blood of the brilliantly coloured species that were being discovered in America, including *L. pardalinum*, the 'leopard lily': 'Go with me in the Coast Range mountains,' wrote the American lily collector, Carl Purdy, 'and . . . I will show you this beautiful lily higher than a man and glorious in its orange and red bloom . . .' *L. pardalinum giganteum* can be glimpsed in Blackadder's bright lily watercolours with its reflexed red petals and yellow, leopard-spotted throat.

The lilies that scent the air in her Edinburgh garden and tower and glow in her paintings are a richly varied company. Of course some of them are hybrids. There is a

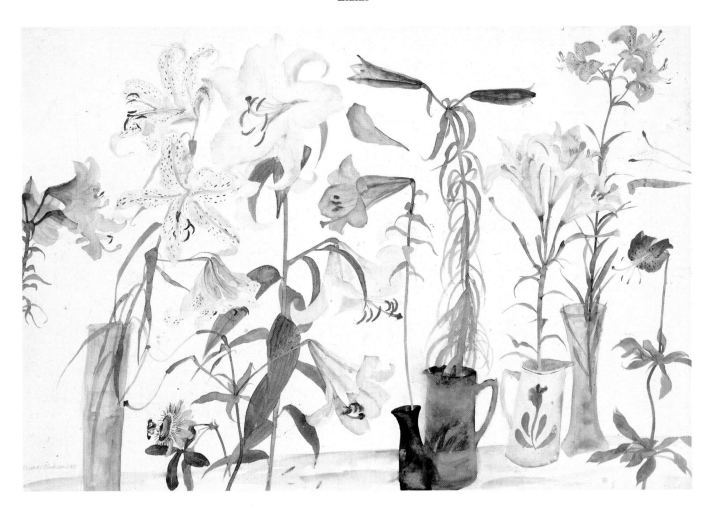

LILIES AND PASSION FLOWER, 1988

tawny version of *L. regale* called 'Royal Gold'; and a chartreuse-tinted one called 'Green Dragon': the New Zealand hybrid 'Journey's End' looks ready to *start* on a journey, pink as the dawn but deeply banded and speckled with wine. A ravishing representative of the 'African Queen' strain turns its soft apricot trumpet half away from the viewer, its buds flushed mahogany brown. One of its parents is the reliable old pale orange species, *L. henryi*, which stands to one side in a thin glass vase, holding its three Turk's-cap flowers high.

For the tall, straight lilies of these paintings are mostly wild species. Supreme amongst them reigns the stately tiger lily, *L. lancifolium.* It was one of the first lilies to reach the west in the great nineteenth-century migration, arriving in England from Canton in 1804. Its flowers are held well out from the strong, dark stem on long pedicels; the six petals re-curve upwards and the six long stamens curve downwards in an answering movement, the dark anthers attached at mid-point so that when a pollinating insect touches them, they can move to and fro. Gertrude Jekyll pointed out that its colour is rare, 'a soft salmon-orange, that can be matched by but few other flowers.' Sometimes Blackadder detaches a single flower and shows off its dark brown spots so convincingly you feel that if you ran your fingers over them you would detect that they stand up a little from the petal's surface.

But there are two old species in these paintings dating from long before the influx from the east began; they are almost as old as *L. candidum.* One is the tall martagon lily, a gentle woodlander with small, mauve-pink Turk's-cap flowers and leaves arranged in

whorls. The other is *L. chalcedonicum*, also a tall Turk's-cap, but sealing-wax-red with leaves lying close to its stem.

Height is part of the lily's distinction. Like the male dancer who lifts the ballerina high, the tall strong stem is an essential partner to the flower. Nothing is allowed to distract, there is only one stem; it carries the leaves as well as the flowers. Economy of effect combines with opulence. And though the flower shares its six-petalled structure with tulips, iris, fritillary and amaryllis, it stands proudly apart from them, and from all other flowers.

In the garden one sort of lily should be kept away from another. But paintings are different. Elizabeth Blackadder arranges lilies together to produce a harmony of slender dark leaves and bright, curving petals, dancing anthers and straight stems, movement and stillness.

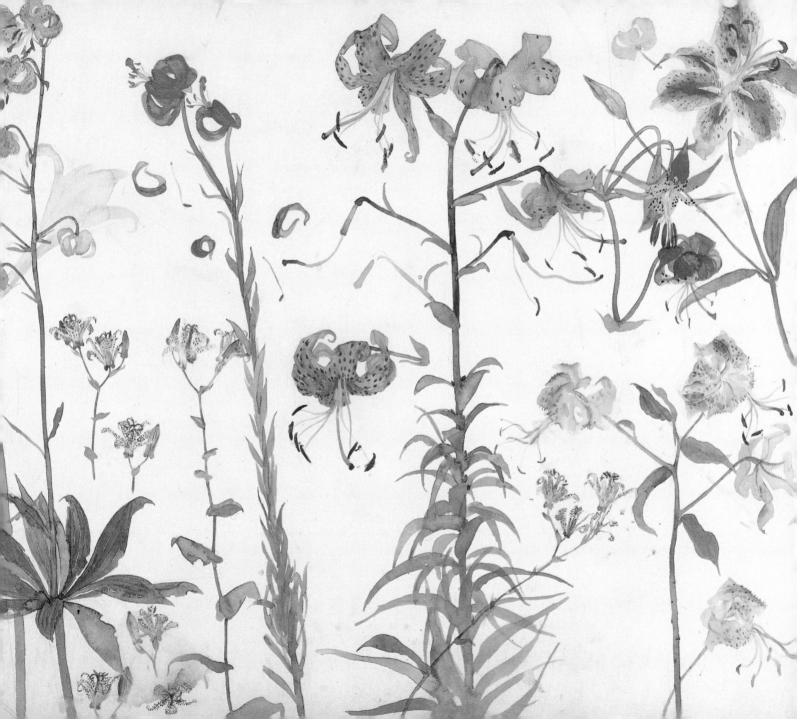

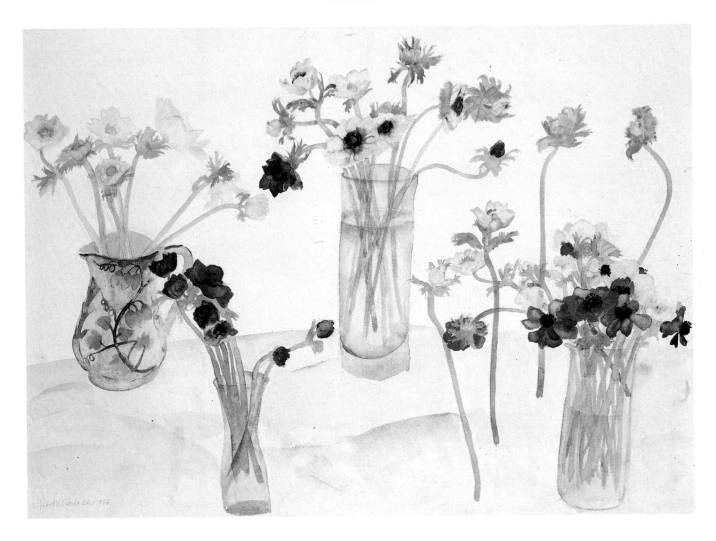

ANEMONES, 1984

ANEMONES

Scarlet and white anemones are there, some born of Adonis'
blood, and some of Aphrodite's tears.
JOHN ADDINGTON SYMONDS, 1919

THE ANEMONE is associated with sadness as well as with spring. When scarlet *Anemone coronaria* opened overnight in its thousands on Mediteranean hills and valleys, people said it was the blood of the dead Adonis pulsing back again out of the earth. Or else they said it symbolized the blood of Christ; in paintings of the Crucifixion, the anemone is sometimes seen at the foot of the cross. The word 'anemone' is thought by some to be a corruption of Nemesis, the goddess of retribution; but it also derives from *anemos*, the wind. Extraordinary superstitions cluster round it: Pliny thought the flowers would only open if the wind blew on them. A seventeenth-century Dutch gardener, van Oosten, advised people to gather anemone seed when the wind was southerly if they wanted double flowers: 'If it be the least point in the North, the Seed will produce only single flowers,' he said.

By the seventeenth century the question of whether an anemone was single or double was crucially important. Like the tulip, it had become a 'florists' flower'. It was cultivated to precise standards and hybridized, and plants changed hands at inflated prices. The De Caen variety was raised in France round Caen and Bayeux and was predominantly single; this was the sort most favoured in England in the seventeenth century. But by the mid-eighteenth century doubles were being imported from Holland as well, for doubles were the Dutch favourites, and if they could be shaded and variegated as well, red splashed with white, they were more sought-after still. In the great Dutch flower-pieces, anemones are so large, so double and so showy that a modern viewer might mistake them for oriental poppies.

Indeed, these anemones are often called 'poppy-flowered'. Their inky-black centres are the loveliest thing about them, a flattish, domed boss ringed by innumerable stamens, each dotted with an important, indigo anther. The petals (or rather the 'segments', for it is hard to distinguish calyx and corolla in the anemone flower) are rounded, sometimes overlapping like tiles, and hollowed to hold and frame the centre.

They cannot hold it for ever. Elizabeth Blackadder accepts their vulnerability – their elastic stems, the way the ageing flower opens flat, the way the bud is half-hidden by the stiff parsley of the three-leafed whorl on the stem. In her painting, the black centres become points of energy in a still space, the flowers bow to each other, some of them have escaped from their vase and seem suspended in the air.

Anemone colours are intense and clear as jewels: amethyst, ruby, garnet, pearl. But one day someone sent Elizabeth Blackadder a whole bunch of white anemones with green centres and she made them into a pale picture with a subdued poetry, all the more haunting because the colour has drained away. The greeny-white anemone is called *Anemone* De Caen 'The Bride'.

All these poppy anemones went out of fashion in the nineteenth century, but are back again in modern flower shops. We buy them because they come in winter when flowers are scarce, because they are long-lasting and relatively inexpensive, and because it is fun to watch the dry-looking buds unfold day by day and release their colours like Japanese paper flowers in water. On the whole we do not grow them; they are not as adaptable as the little blue and white ones of early spring, *A. blanda* and *A. nemorosa*, which spread in our gardens but have not got the knack of surviving as cut flowers and will not wait for the artist's brush to catch them.

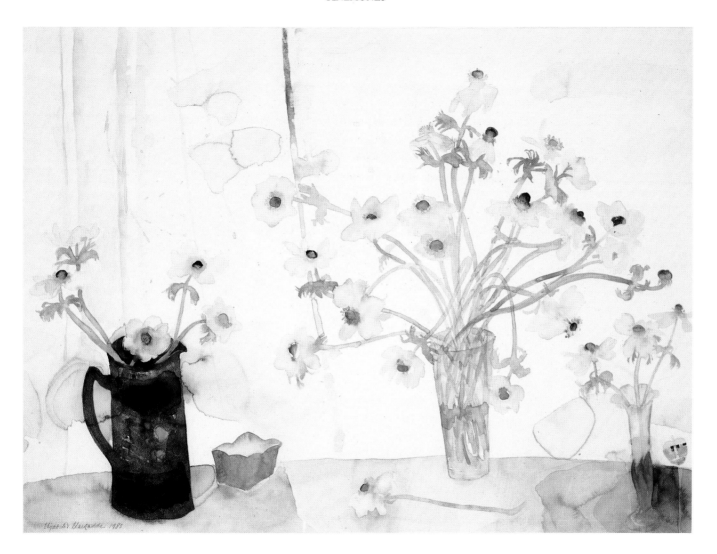

ANEMONES, 1983

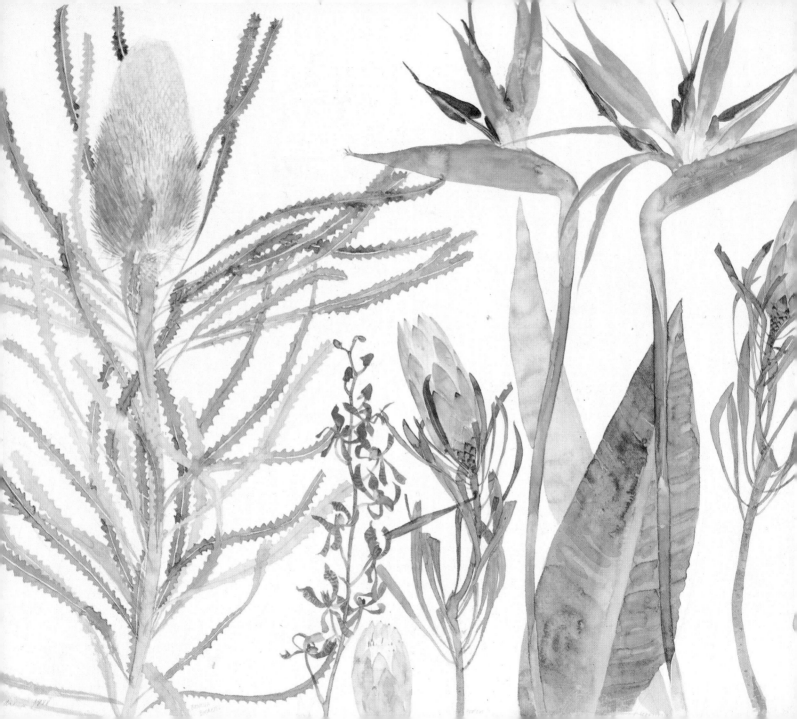

BANKSIA

From far and near they came, all sorts and kinds of Wild
Bad Banksia Men. Long, thin red ones; great nobby brown
ones; fat, round, green and grey ones; short, thick, black
ones; yellow ones and some almost white.

MAY GIBBS, 1923

AUSTRALIAN CHILDREN born in the '20s and '30s of this century were likely to know, and fear, the Banksia Men. They were the cruel villains of a series of picture books peopled by Australian fauna and flora. They were made from the strange fruits of the banksia: crude, bristly cones dotted with woody follicles, which became, in May Gibbs' drawings, obscene, fat lips and leering, protuberant eyes.

So a generation of Australian children, brainwashed to dislike banksias, raced blindly past them through the thick white sand where they grew to reach the sea. Not so Captain Cook and Joseph Banks, with their accompanying artist, Sydney Parkinson, when they landed on those beaches in 1770 and began to walk, astonished, through the bush. Banks found five different species of this strange new genus which was to be called after him; he pressed and dried specimens and Parkinson began his watercolour studies. Cook called the place where they anchored 'Botany Bay'.

Subsequent explorers found more and more banksias, until today seventy-three species have been named: tall trees, huge bushes like bell tents, prostrate shrubs. When Matthew Flinders brought the botanist Robert Brown and the great botanical artist Ferdinand Bauer to the shores of south-west Australia in 1801, they found eight new banksias and Bauer drew with meticulous skill the structure of two extraordinary flowers: the red and grey *Banksia coccinea*, shaped rather like a sea-urchin and patterned like elaborate

STRELITZIA AND BANKSIA (DETAIL), 1988

beadwork and fringing, and *B. speciosa*, a huge cream and pale yellow thimble. Bauer had a good microscope and so could supply detailed close-ups at the bottom of his page.

Banksias belong to the family of Proteaceae, and share the protea's prickly glamour. The flower-spike is a repetitive sequence: hundreds, even thousands, of tiny flowers in pale yellow, brilliant orange or even vermilion, arranged in spirals and vertical rows on a central core. The bottle-brush effect comes from wiry styles, which are looped into the flower-buds until they open, and are then released to stick out all the way up the spike; the tips are a different colour from the hairs; the hairs are a different colour from the petals; the petals are a different colour from the central core; thus you may glimpse a deep green core through yellow flowers which are themselves glimpsed through red styles with yellow tips. When a flower-spike is only half open, the tight-closed buds at its top will be a different colour from its base. It is all a question of subtle tonal shifts and harmonies.

The evergreen leaves are dark with downy undersides, white or silver-grey; they are velvety rust or pink when young. All manner of serrations occur along the leaf edges, prinkings and rollings or fine-cut triangular lobes, like ricrac trimming. They are usually narrow but sometimes broad, usually hard and tough but sometimes undulating. They can remind people of the leaves of heath or spruce, a serrated thistle or a broad-toothed oak leaf, or a pine-needle – or plaited dread-locks, or a feather. Elizabeth Blackadder sees them as graceful, exquisitely cut, and with a rhythmic undulation like seaweed under water. Of course she cannot grow them in her Edinburgh garden, but since the recent farming of banksias for the cut-flower trade, she can buy them in a local florist's shop.

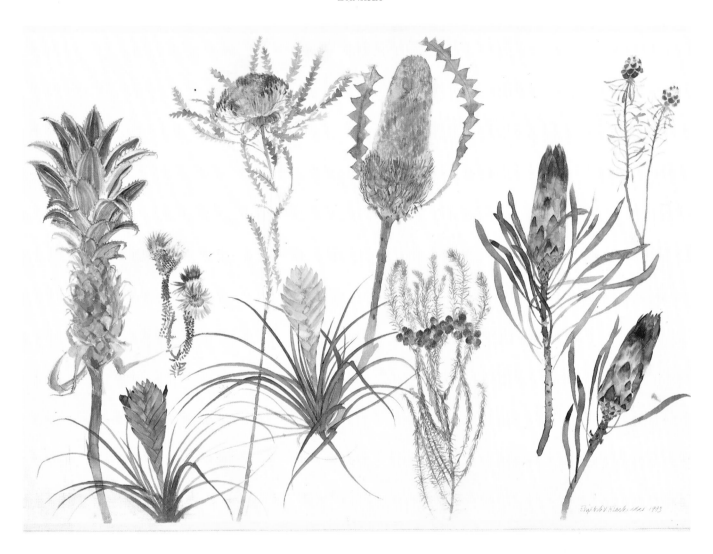

BANKSIA, TILLANDSIA, PROTEA, ANANAS (1993)

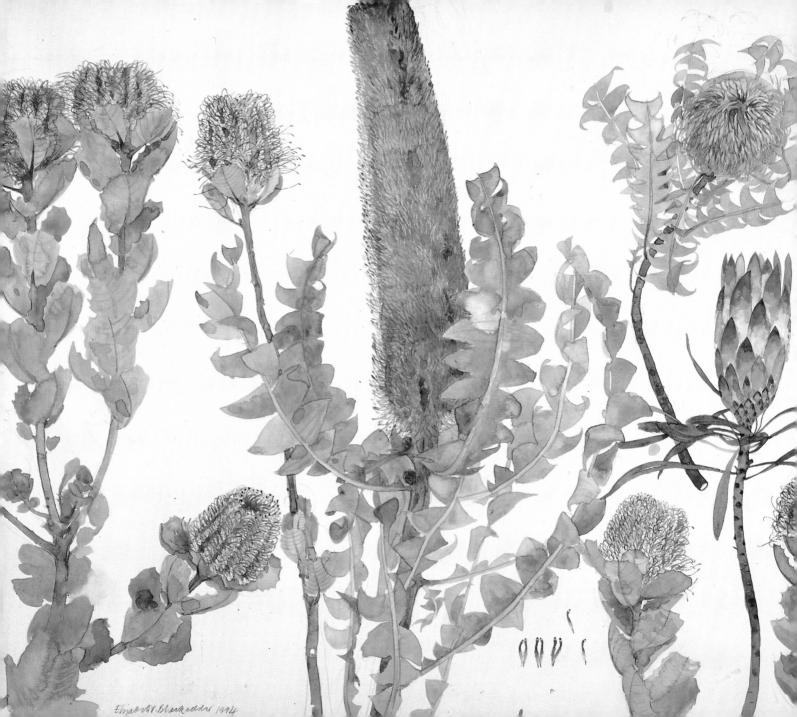

Elizabeth V. Blackadder 1994

'Showy and useless strangers', Dr Lindley called them in his *Botany for Ladies*. Strangers they remain, but it is not fair to call them useless. They have the mysterious power of regeneration after fire, which makes them singularly adapted to the Australian bush: some species spring afresh from their fire-tolerant trunks or from a woody stock called a 'ligno-tuber'; others renew themselves from seed. It takes the heat of an Australian bushfire to open those tight-shut follicles – the rounded wooden lips of the Banksia Men, who prove themselves not bad, but life-giving, when their seeds fall on the cooling earth.

BANKSIA AND PROTEA (DETAIL), 1994

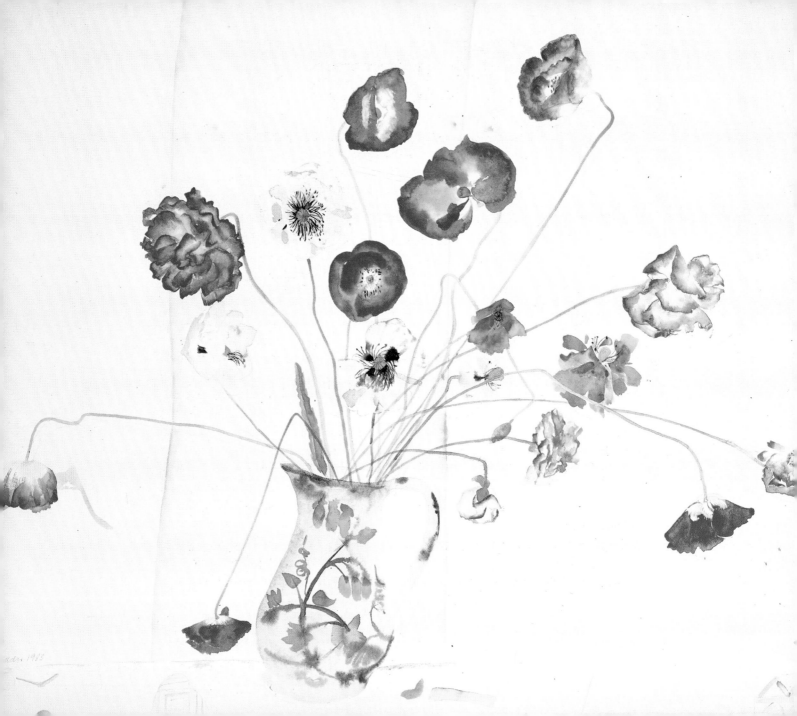

POPPIES

*Gather a green poppy bud, just when it shows the scarlet
line at its side; break it open and unpack the poppy. The
whole flower is there complete in size and colour, – its
stamens full grown, but all packed so closely that the fine
silk of the petals is crushed into a million of shapeless
wrinkles. When the flower opens, it seems a deliverance
from torture; the two imprisoning green leaves are shaken to
the ground; the aggrieved corolla smooths itself in the sun,
and comforts itself as it can; but remains visibly crushed and
hurt to the end of its days.*

JOHN RUSKIN, 1879

ANYONE WHO KNOWS a poppy knows this: the bud has a hairy casing, two lobes which part to show the brilliant crumpled petals, and disappear when the flower opens; they simply drop to the ground, and the poppy – scarlet in the field, all sorts of colours in the garden – opens out. Conflicting emotions cling to it. It stands for oblivion, and remembrance. It has been called 'the plague of the careless farmer . . . the scourge of half the world.' It is the attribute of Hypnos, the god of sleep, and of Morpheus, the god of dreams and night. The goddess Ceres appears in pictures wearing a wreath where poppies are mixed with corn so that she can periodically rest from her labours and visit the underworld. How strange it is that such an innocent, bright flower should be an emblem of the dark!

Once there was an English clergyman called the Rev. W. Wilks who lived at Shirley in Surrey. One summer's day in 1879, he found a poppy with white-edged petals growing amongst other field poppies – forms of *Papaver rhoeas* – in a wild corner of his garden.

SHIRLEY POPPIES IN A JUG, 1983

From this poppy, by a process of repeated selection, he produced his race of Shirley poppies in pink and salmon and orange-red and rose and white. He eliminated any with black blotches in the centre; he was after silken lightness and transparency, gold-dusted anthers against white-centred petals. He did not breed doubles: they came later in modern strains, and will be there in the seed packet of Shirley poppies that you buy today.

If, like Elizabeth Blackadder, you pick a bunch of these poppies and put them in a jug, their life will be fleeting. The petals seem too light to hold to their centre; they fall, along with a rush of yellow pollen, and you are left with the wiry, hairy stalks and the hard capsule of the seed-head, which has much greater staying power. But there are ways of making poppy flowers last in water, at least for three days. Pick them in the evening; pick them in bud, when the sepals are only just beginning to split; burn the ends of their stems, or dip them for a few seconds into boiling water. E.A. Bowles used to carry a jug of hot water out into his garden after dinner and put the poppies into it as he picked them. He left them standing in his bathroom all night and next morning watched them open and arranged them in a vase.

Poppy stems and poppy leaves have a milky fluid in them which bleeds when they are cut, unless they are sealed by heat. It is latex, and when it is extracted from the glaucous,

SHIRLEY POPPIES (DETAIL), 1985

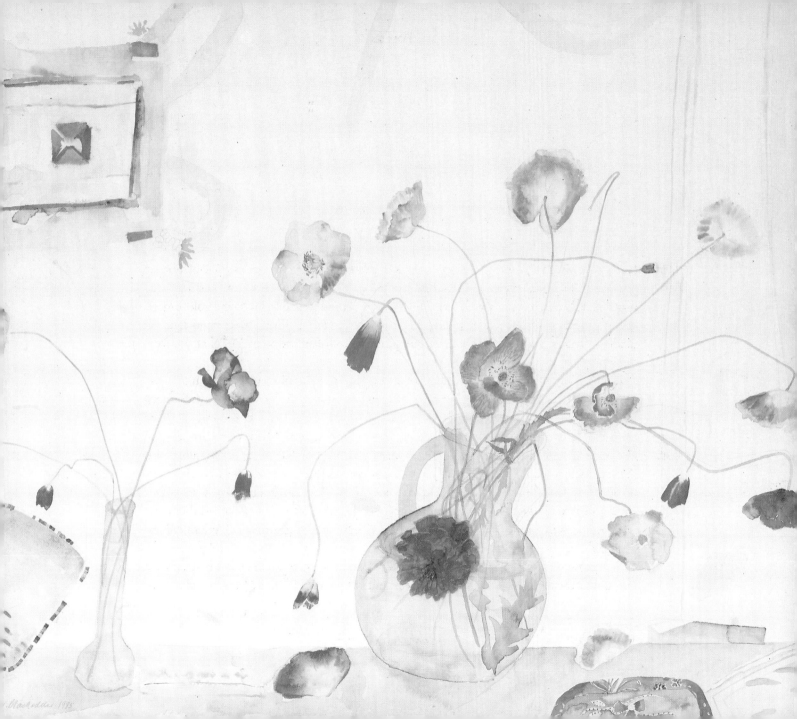

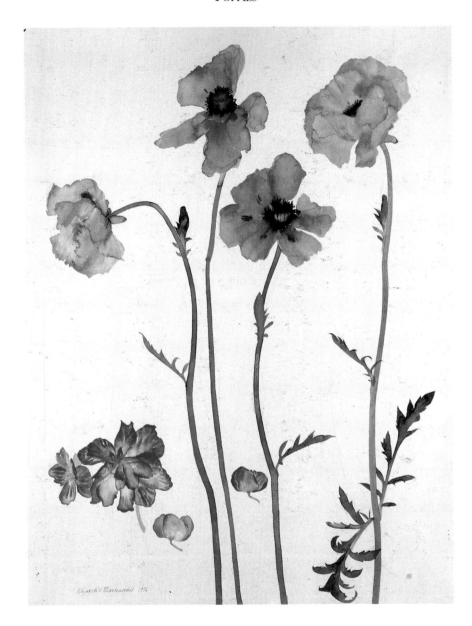

globular seed-heads of *Papaver somniferum* it produces the red-brown, bitter drug that is opium. *P. somniferum*, the opium poppy, is an ancient plant, well known to the Romans; in the nineteenth century it was grown in Britain as a field crop for the production of laudanum. Its addictive properties were still not understood.

The great, blowsy poppies of seventeenth-century Dutch flower-pieces are double forms of *P. somniferum* whose seed had recently arrived in Holland from Constantinople; they were being propagated with names like 'Carnation Poppy', 'Curled Poppy', 'Fringed Poppy', 'Feathered Poppy' and there is scarcely a floral still-life without one; you can often distinguish it from a peony or a double anemone by its accompanying buds, typically bending their heads over like a shepherd's crook. Some art historians believe that there is an awareness of *Vanitas* in certain of these paintings (notably in Jan Davidsz. de Heem's *Vase of Flowers* in the National Gallery, Washington). Here the poppy seems to play a slightly sinister role. Flamboyant though it is, large and double, it is a reminder of the brevity of life, the certainty of death. At the top of the canvas it is just opening, white fringed with scarlet; at the bottom its blood-red petals are about to fall. And as if to rub the point in, there is a convolvulus near by, an emblem of the morning to contrast with the poppy's night.

Surprisingly perhaps, Elizabeth Blackadder's Shirley poppies have a life-affirming gaiety; they are not ready to die. Though her garden is full of self-seeding opium poppies, she has not yet painted them. Poppies are the subject of some of John Houston's paintings, and it is he who allows *P. somniferum* to spread through the flower border; he eradicate's only the dingy or sickly-sweet pink ones. He also grows the gorgeous oriental poppies (*P. orientale*) which were first imported from Armenia in the early eighteenth century. They are field poppies on an enormous scale, with typically vermilion petals blotched with black round a great boss of trembling purple-black stamens. But since Amos Perry began to hybridize them, they can now be had in pink or white as well, and the four in Elizabeth Blackadder's painting are pale salmon, a gentle rather than flamboyant colour. They are not allowed to flop; the lines of their tall stems and toothed, bristly leaves make a serene design (see p.74).

The scarlet token in our lapels on Remembrance Sunday is correct in its simplicity but misleading in its flatness: most poppies have only four petals (though sometimes there are six), but they form a cup surrounding a crowd of stamens and a single ovary with a sort of star or cross (formed by the stigmas) on top. When the petals fall, the ovary hardens into the poppy-head that has been painted and used in ornamental art at least as often as the flower. Botticelli's Infant Christ carries it in his hand.

There are many sorts of poppy, but you can recognize the flower immediately by the 'visibly crushed' silk of its petals, its cupped shape and the hard seed-head capsule. Until this century, you could be fairly certain of its colour range too: it might be white or

yellow, but more commonly orange, red or pink. And then, in 1926, there was a sensation so great that it made the front pages of the press. The blue Himalayan poppy had arrived from Tibet and could be seen at the Chelsea Flower Show in London.

It wasn't just blue: it was the most heavenly, exquisite blue in the whole plant kingdom, or rather a shaded sequence of blues from turquoise to sky. There was an element of astonishment in the reaction to this colour. How *could* a poppy be blue? The plant-hunter Kingdon-Ward had rediscovered it in 1924 (in fact the Abbé Delavay had brought a specimen back to Paris some time before, where it had been named *Meconopsis betonicifolia*). Though Kingdon-Ward was enraptured with the plant, and proud that it quickly won horticultural awards, his perfectionism made him find fault with it in the end. 'The flowers are beautiful beyond belief,' he wrote in *The Romance of Gardening,* 'with a fountain of golden stamens shivering and shimmering in the centre; but they are too volatile. Within a fortnight of the clump's opening its first flowers, the plants are beginning to look shabby . . . Is that crowded fortnight of glorious life worth fifty weeks of oblivion?'

The answer is surely: yes, if you can grow it. For after all, it is in the nature of poppies to be fugitive.

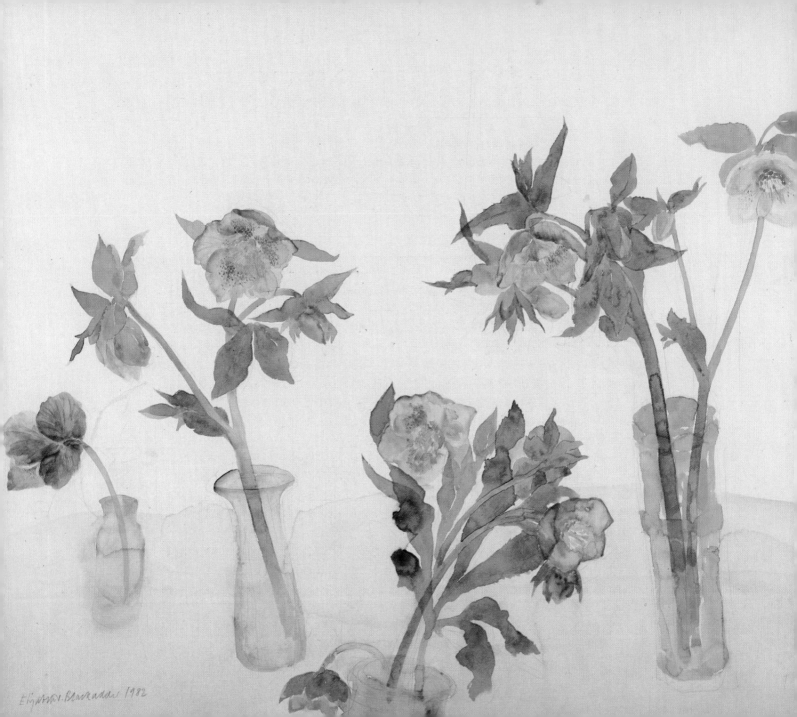

HELLEBORES

A purgation of Hellebores is good for mad and furious men,
for melancholy, dull and heavie persons, and briefly for all
those that are troubled with black choler, and molested
with melancholy.
JOHN GERARD, 1597

T HE HELLEBORE is an ancient plant, perhaps introduced into Britain by the Romans, and anciently esteemed for its medicinal properties. Deadly poisonous, particularly in the root, it was feared, revered and mythologized. Theophrastus advised anyone who proposed to cut a stem to stand to the east of the plant and say a prayer before doing so. At one time cattle had to endure having a piece of hellebore stuck through a specially made hole in the ear if they were sick. Of course it was prominent in herbals, and great botanical illustrators like the Frenchman Nicolas Robert made strong, dark engravings of its serrated leaves and substantial, moulded flowers, but you will not find a painted hellebore in a Dutch or French decorative still-life, for the good reason that, until the nineteenth century, it was not regarded as decorative.

Today it is wildly popular. If we still talked about 'florists' flowers' in the old sense of collectors' specialities, then the hellebore would surely be *the* florists' flower of our age. One devoted hybridist admits to a sort of hellebore fever that descends each spring as she waits to see what colour her new seedlings will be and what markings they will have on the inside of their sepals.

For hellebores have five sepals and no true petals. That may explain their curiously sculpted air of permanence. The colours most prized and pursued in patient cross-fertilization and selection programmes are pale, clear yellows, inky, blackish blues, pale

HELLEBORE ORIENTALIS, 1982

brown café-au-laits, and ravishing two-toned effects where the outside of the sepal may be smoky violet and the inside chartreuse green.

As is the way with 'florists' flowers', these crosses fetch high prices; but you have only to look at Blackadder's painting of *Helleborus orientalis* hybrids to be reminded that unpretentious, unnamed seedlings have beauty enough. She catches their pearly texture, the palette shading through pinks to greenish creams; she shows the darker depths of dull rose on the back of the flower, the sunburst of yellow stamens in the centre where the sepals shade to apple green.

Helleborus orientalis used to be called the 'Lenten rose'. It grows up out of the soil on a strong stem long before Lent, and its leaves come a little later on on separate stems. But there is another class of hellebore where leaves and flowers share the same woody stem and Elizabeth Blackadder has painted one of them: *H. argutifolius* (*H. corsicus*) whose trifoliate leaves are stiff and toothed, dark green and arched with clusters of pistachio green flowers nestling amongst them. In bud, as she shows, these flowers seem slotted together or concertinaed into a single curving inflorescence where the leaf bracts are exactly the same green as the globular, drooping buds. There may be a dozen flowers to a raceme; they last in the garden for weeks; hanging their heads at first but straightening when the golden stamens fall and five sharp, urn-shaped carpels take their place.

Both *H. orientalis* and *H. argutifolius* are easy garden plants in sun or shade, town or country, and may still be relied upon to lift the spirits of those who, at the start of the year, find themselves 'molested with melancholy'. They act, not through poisonous purgations, but through beauty.

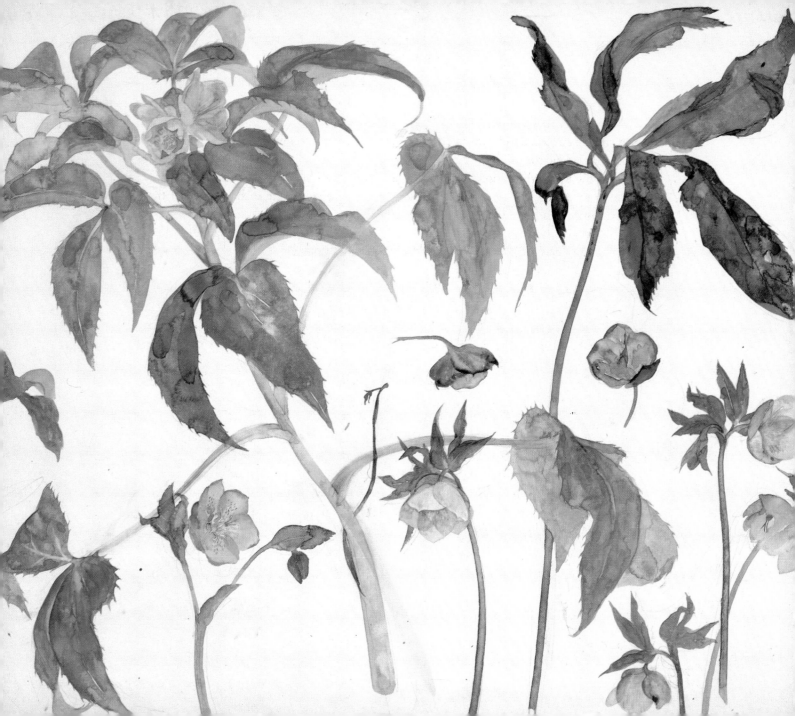

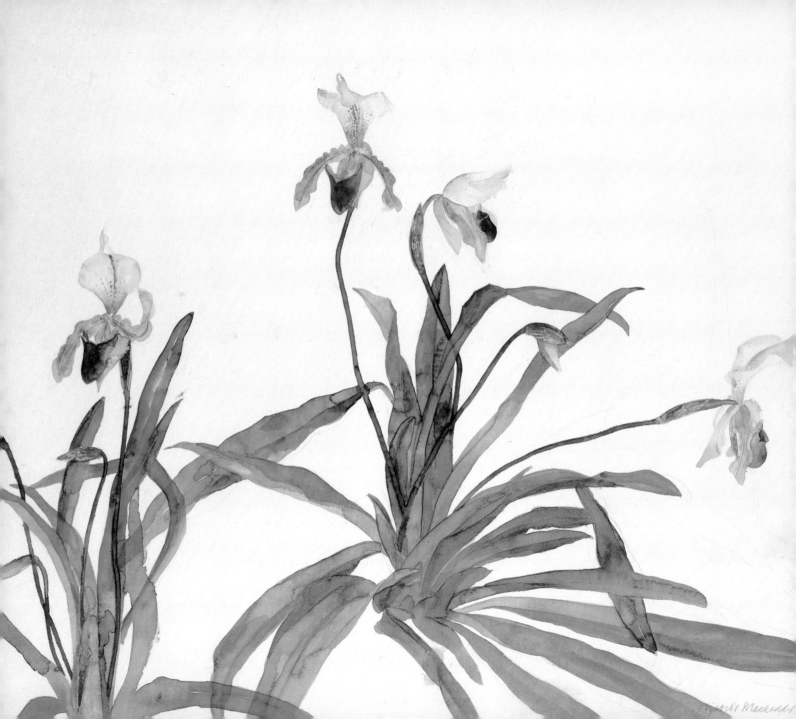

ORCHIDS

. . . a whole shower of pale purple and white butterflies,
coming down from a bough . . . Their forms are beyond
everything astonishing. The monkey, the mosquito, the ant,
are only a few of them; there are hovering birds and every
wondrous shape, so that travellers declare that the life-time
of an artist would be too short to give pictures of all the
kinds that inhabit the valleys of Peru alone.

CHARLOTTE M. YONGE, 1853

THE ORCHID KNOWS what it is doing. If it mimics an insect, it is in order to attract it into its heart. Then it may put the insect through an assault course of trap-doors, triggers and slides until finally the aim is achieved: the insect emerges with a pellet of pollen stuck to its tongue as if with super-glue, only to be released against the specialized stigma of the next flower. So puzzlingly perverse seemed the pollination of some orchids to nineteenth-century botanists, that Charles Darwin felt challenged to study and explain it, and wrote a classic work called: *On the Various Contrivances by which British and Foreign Orchids are Fertilised.* He was refuting the theory that the orchid is a practical joker because sometimes it has a spur like a nectary which turns out to have no nectar inside it. Yet some orchids do look like clowns – or jesters, all yellow and orange stripes. There are orchids that look like moths, or spiders, or lizards (their common names, so much easier to remember than their scientific ones, reflect these likenesses); then there are orchids that imitate other flowers like pansies, irises or lilies, and white orchids that seem to be suspended in the air like comets with long tails, or showers of stars sending out wafts of heavy perfume to attract night-flying moths.

PAPHIOPEDILUM (DETAIL), 1988

83

It is the biggest plant family of all, surpassing even the pea. There are at least 15,000 species. Its members grow all over the world, on Chinese mountains, in India, Malaya, Florida, Australia, or springing up in the grass of a neglected English tennis court. But it is the tropical orchids of rain- and cloud-forests in Madagascar, Panama and South America that bewitch and tantalize people, the orchids that trail, hang or swing from tall trees: 'epiphytic' orchids, which are now alarmingly under threat from over-collection and deforestation. These orchids are not parasites: they draw no sustenance from their hosts; they simply anchor themselves to branches to get a little nearer to the light.

When plant-collectors first started sending their specimens home, many perished *en route.* Those that survived died later, shrivelling up under the dry heat of conservatory roofs in summer. Only halfway through the nineteenth century did growers discover how to make their greenhouses right for orchids, with hot pipes, steam and shaded glass. Then the great Victorian orchid craze began: wonderful orchid albums were produced: James Bateman's *Orchidaceae of Mexico and Guatemala* (1837–41), said to be the biggest botanical book ever produced, with hand-coloured lithographs; W.J. Hooker's *A Century of Orchidaceous Plants* (1851), illustrated by W.H. Fitch, followed by Bateman's *Second Century of Orchidaceous Plants* (1867) again illustrated by Fitch. A sort of 'orchidomania' had taken hold amongst wealthy collectors who vied with each other in the number and rarity of their plants and the size of their orchid houses complete with waterfalls, rills, tree trunks, mosses and ferns.

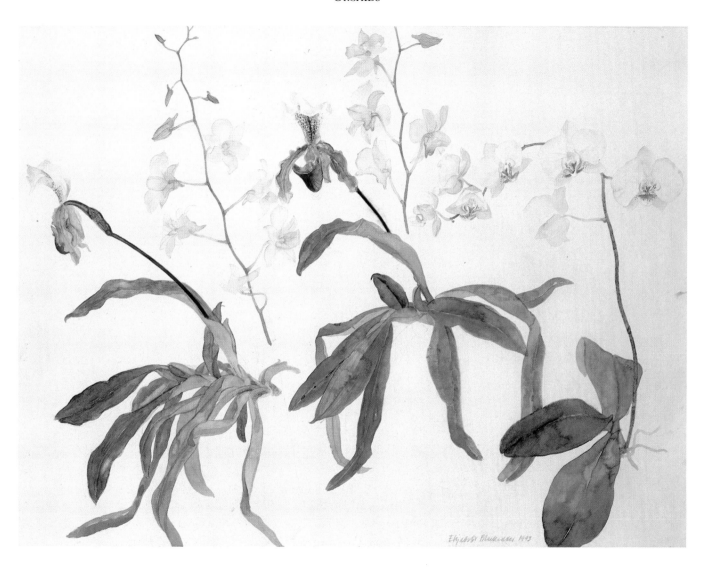

ORCHIDS – PAPHIOPEDILUM AND DENDROBIUM, 1993

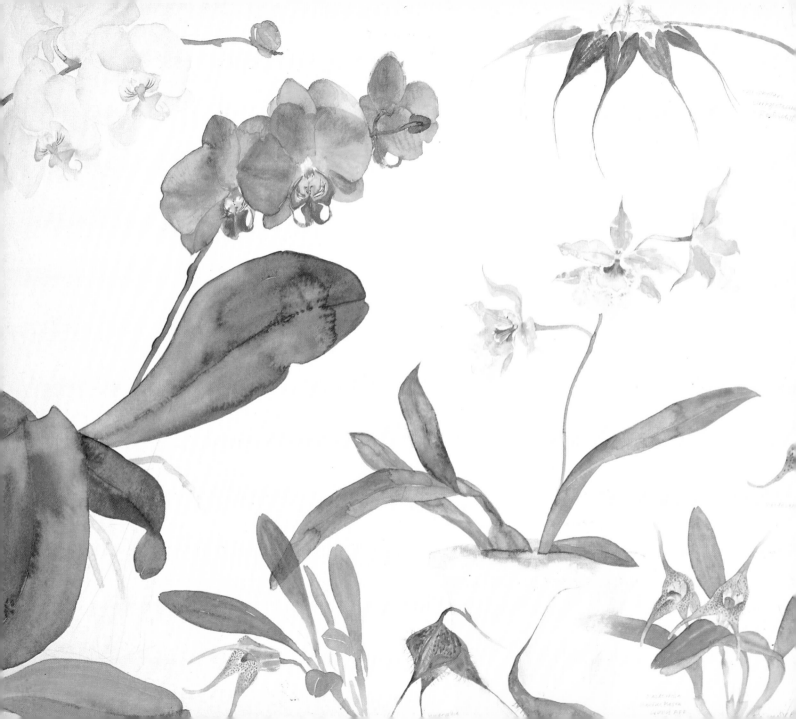

The orchid breathes expense. It stands apart from other flowers, exotic and mysterious; there is no sentimental nostalgia about it, it is at the same time sophisticated and wild. The big, bright mauve, trembling cattleya, wired as a corsage, became a badge of success on the bosoms of the wives of important men, and won the disdain of the fastidious plantsman, E.A. Bowles:

> *certain great flaunting mauve and purple Cattleyas cloy my*
> *nose and annoy my eye till I conjure up a vision of them*
> *expiating their gaudy double-dyed wickedness with head*
> *impaled on stiff spikes . . .*

Elizabeth Blackadder does not behead or impale her orchids, so they never have that corsage look; she allows them their leaves and their natural poise and grace. In her youth she was unmoved by them; then, at Edinburgh Botanic Garden, she was infected by the enthusiasm of the botanist Paddy Woods, felt the visual excitement of the flower, and soon she was looking into the cattleya close-up through a magnifying glass. She has been painting orchids ever since. She has also used them in the teaching of botanic art. 'They last so long,' she says half-apologetically, 'and there are so many different sorts.'

STUDIES OF ORCHIDS (DETAIL), 1988

So many different sorts – and yet they share an underlying structure. It is the simple structure of the 'liliiflorae' – the lily-flowered plants like the tulip, the iris, the fritillary and the amaryllis. In short, it has three sepals enclosing three petals. But the third orchid petal is a distorted oddity, a 'labellum' or lip, often larger than the two other petals, a brighter colour, perhaps spotted or splashed, designed to attract passing pollinators and, in the case of the slipper orchid, to trap them. Sometimes, according to the plant-collector Kingdon-Ward, the slipper is so big that you could put a baby's foot into it. Opposite the labellum and as an extension of it, there is usually a tubular spur containing nectar to entice the pollinators – flies, bees, butterflies, even humming-birds – into it. The flower has what is called 'bilateral symmetry': you could draw a line down its middle and, for all their extravagances, the two halves would be mirror images of each other.

At least three orchids have claims to be *the* orchid of popular imagination. One, of course, is the glamorous cattleya. Another is the cymbidium, with its heavy, waxy flowers that may be creamy primrose edged with plum, piercing lilac, jade green, or dusky pearl, arranged in erect racemes of from six to twenty flowers on strong stems – as if an ordinary gladiolus had been touched by magic. And third, there is the paphiopedilum – the Asiatic slipper orchid. Like the cymbidium, it exists today in countless hybrids, for modern techniques have perfected a system of propagating orchids in sterile flasks which means that we can buy an orchid without robbing a rain forest.

Paphiopedilums stand proudly on their dark and slender stems in many of Blackadder's orchid studies. Sometimes they simply complete a picture with their

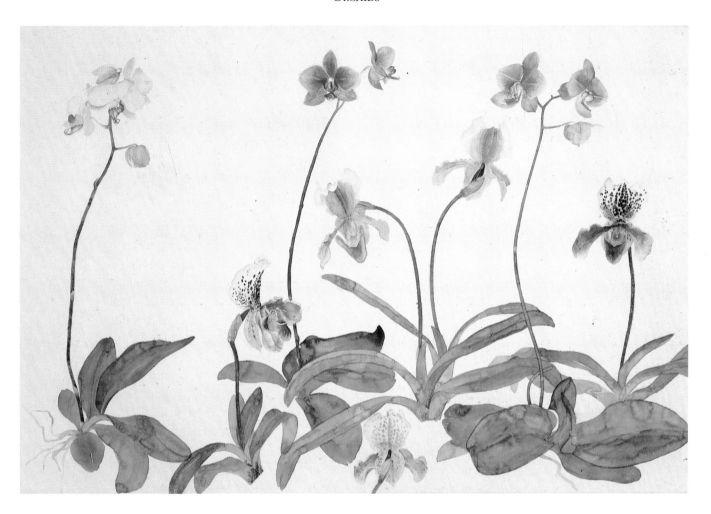

ORCHIDS, PHALAENOPSIS AND PAPHIOPEDILUM, 1991

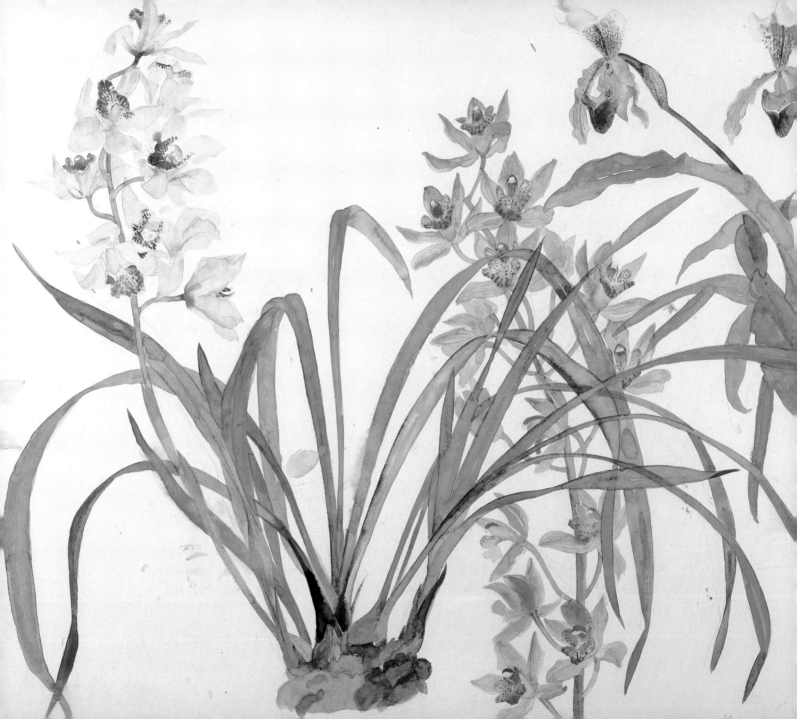

characteristic dorsal sepal raised like a minaret, or rather like a great striped or spotted fan in the Nile scene of *Aida*. Sometimes, they have a painting to themselves, where two clumps of floppy green leaves produce half a dozen tall flower-stems and show off the perfect balance of rich, brown slipper at the bottom of the flower and flaring pale canopy at the top. The flower's symmetry is completed by the two lateral petals, curving out and down. (The two other sepals do exist, but they are hidden behind the labellum, so that the paphiopedilum seems to have only four segments.)

There are other orchids in other paintings: a glamorous pink one and an unexpected blue. The pink is the 'moth orchid', so called because its small lip is divided in two like a moth's wings, with luscious rounded petals framing it. It belongs to the genus phalaenopsis, whose flowers can be white or creamy yellow as well as pink, and is sold in its thousands as an indoor plant producing a succession of long-lasting, winter flowers. In its natural state it has a gravity-defying grace; its inflorescences dangle and cascade from trees like waterfalls or fountains. Potted up in a sitting room it may be tied to a stake – but never so in these paintings.

The blue orchid is a Vanda – an orchid that likes to live high in a tree because it will only flower in bright light. It has succulent, strap-like leaves, dangling aerial roots, and clusters of long-lasting, winter-blooming flowers. But it is said to dislike being restricted

ORCHIDS – PAPHIOPEDILUM AND CYMBIDIUM (DETAIL), 1993

in a pot, and to be happiest fixed at the top of the window or near the greenhouse roof, so it needs a devoted carer.

There are many such carers to be found. Though 'orchidomania' has faded out, along with the great estates where orchid houses multiplied, addiction to orchids remains and is contagious. Even in the nineteenth century people without much spare money were besotted, and became the reading public for a series of articles called 'Orchids for the Million' in the *Gardeners' Chronicle* (1851). Today's addicts convert small back-garden sheds into orchid houses, sometimes with controlled mist jets and fans to circulate the air; they sink old tree-trunks into concrete and wire their epiphytes to them, the roots wrapped in sphagnum moss. It becomes a way of life. Yet moderation is possible: you can grow a single orchid successfully on a window sill in a tray of damp gravel in a centrally heated room.

There have always been a few voices raised against the orchid, for it is extreme, and invites extreme reactions. Ruskin wrote aggressively about the 'livid and unpleasant colours' of terrestrial orchids; indeed he warmed to his attack on them, using words like 'ugly', 'disagreeable', and even 'malicious' and 'degraded'. He described one orchid as putting its lip far out 'as a foul jester would put out his tongue'. But he praised the simple orchids of English meadows – and Elizabeth Blackadder paints these too.

ORCHID – BRASSOLAELIOCATTLEYA 'JUNE MOORE', 1980

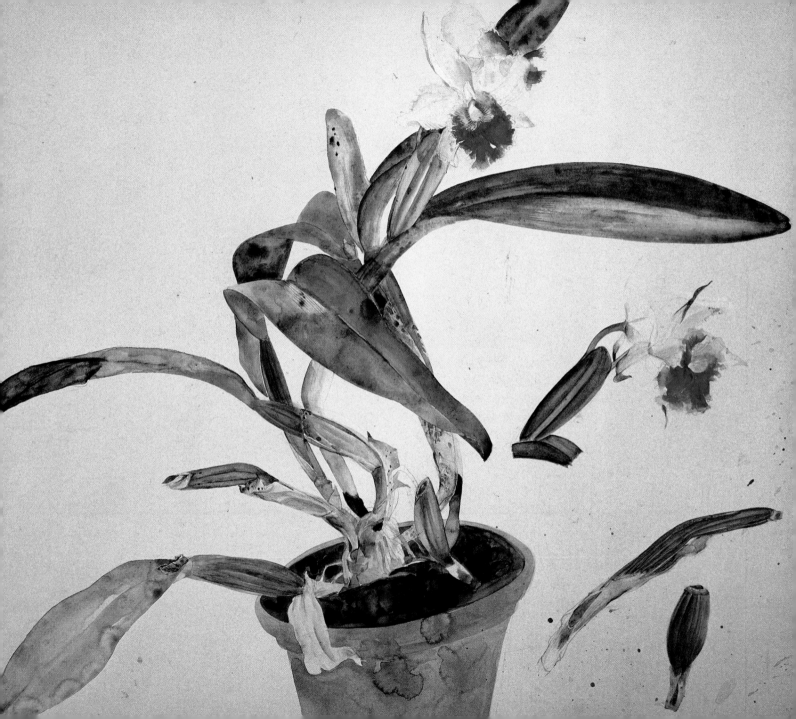

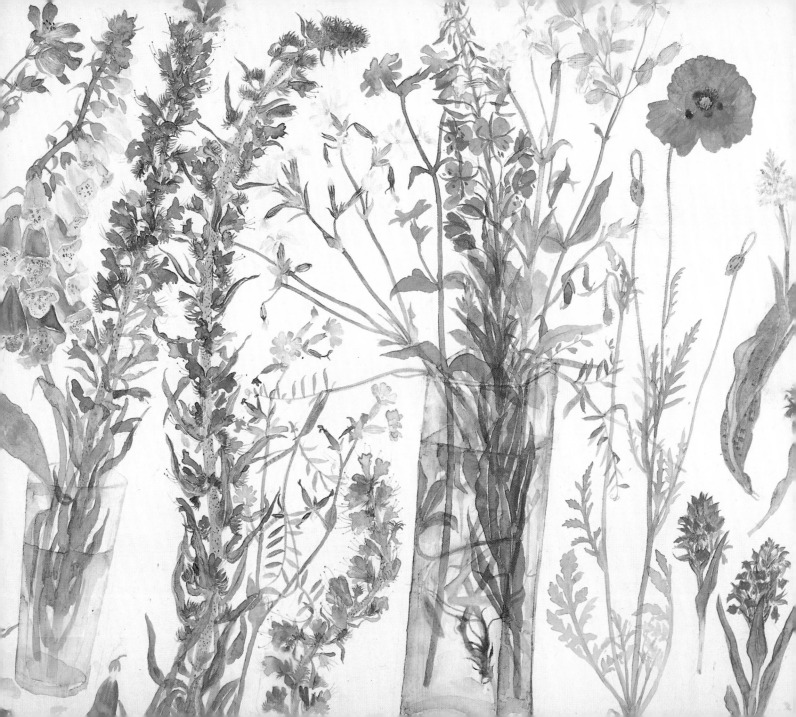

WILD FLOWERS

*Always suspect the credentials of the 'flower-lover' who
despises weeds.*
WILFRED BLUNT, 1975

HERE IT IS, the wild, rosy-mauve orchid of our meadows. And here, beside it, is the field poppy on its tall, wiry stalk, complete with two drooping buds. Its face is turned towards us so that we can check the number of its petals (four) and the blackness of its central blotches. Then comes the rose bay willow herb, a coarse old thing, but indomitable (it was the flower that turned the bomb sites of London pink in World War II). It shares a vase with two campions: one pink, the other white – the bladder campion with mushroom-coloured calyces and drooping flowers. The tall, wild echium, viper's bugloss, arches towards the poppy and answers its extrovert scarlet with intense, inward blue. There is a dainty little vetch beside it with pink pea-flowers and delicate pinnate leaves. The foxglove spike takes a sinuous, serpentine pose round a little mauve meadow cranesbill in the corner; its topmost flowers are still in bud, but already two spotted flowers have fallen.

Wild flowers have had their portraits painted since botanical illustration began. Under the scrutiny of the artist's eye, thistles have turned into things of beauty. Redouté painted the humble daisy to illustrate J.J. Rousseau's *La Botanique* and made of it an exquisite picture, its flowers turning this way and that, its leaves gracefully drooping down the page. Ferdinand Bauer painted the dead nettle, *Lamium maculatum*, so sensitively that it is seen to be a soft and subtle plant. Elizabeth Blackadder's chosen specimens have charm

WILD FLOWERS – VIPER'S BUGLOSS, FOXGLOVE, CRANESBILL, POPPY, CAMPION, VETCH,

ORCHID, WILLOW HERB (DETAIL), 1993

and grace, as well as convincing life. When she was a schoolgirl, she used to collect the wild flowers that grew near her home, press them, arrange them in a book and label them with their botanical names. Now she paints them with the same regard for their identity that she has always had and the enviable skill that can fix each frail flower in paint.

But the best way to show off a wild flower is to arrange it with other wild flowers, as any child knows who has picked an assorted fistful along a country lane. Elizabeth Blackadder has filled the page with them from side to side, so that it is at once a still-life, a botanical study and the flowery mead of medieval dreams. As soon as we see this picture, we feel that we have known it always.

Brief Cultivation Notes

AMARYLLIS see HIPPEASTRUM

ANEMONES (De Caen and St Brigid): Soak corms in warm water overnight, then plant 5cm/2in deep with the cluster of tiny, dark crowns pointing upwards (if you can see them!) in well-drained humus-rich soil in a warm spot. Tread soil to firm them after planting, and feed fortnightly with liquid fertilizer when they start to flower, but don't expect them to last for ever. Worth trying in a sunny window-box.

BANKSIA If you live in Australia, you can grow a variety of glamorous banksia trees and shrubs in well-drained, sandy loam and thus attract birds – honeyeaters and lorikeets – to your garden. In temperate climates you may settle for cut banksia flowers from a florist (they last well in water) or for the spectacular dried flower-heads, the colour of salty driftwood, in which there is now a thriving trade.

FRITILLARIES Plant as soon as you receive the bulbs. They all like well-drained soil, alkaline rather than acid, and most prefer sun. Plant crown imperials 15cm/6in deep, smaller bulbs rather shallower, though the deeper the planting, the better they seem to do. Disappointing, non-flowering fritillaries can often be cured with dressings of sulphate of potash every two or three weeks until the leaves die down. *F. meleagris* can be lifted, put in a bowl and brought inside to flower. For cut flowers, dip stem-tips in boiling water for a second.

HELLEBORES Prepare a deep hole in humus-rich soil and plant so that the junction of roots with crown is 2cm/¾in below the surface. Water well and mulch. In its first spring, feed generously with liquid fertilizer. In subsequent years, remove all the old leaf-stems when new growths get under way; this guards against 'black spot', but if it comes, spray with systemic fungicide.

HIPPEASTRUM Plant in a pot not much bigger than the bulb's circumference, holding it quite high while you firm damp potting compost round its dangling roots; only its lower half is buried, its upper half remains visible. Place in the warmth and do not overwater until green shoots appear. Then increase watering and feed weekly. It likes light as well as warmth.

IRISES Bearded irises need sun, good drainage, humus and replanting. They grow from vigorous cylindrical rhizomes which

quickly multiply, plaiting themselves over each other. Every third year, lift them after flowering and replant the youngest fans of leaves, placing the tuber pointing towards the sun and barely covering it with soil; press the white roots down into troughs in the soil on either side. Cut the leaves down by half so that they won't be blown about before the roots have re-fastened themselves. Every year, gently pull off all old leaves and burn them (they may harbour the fungus disease that makes them turn miserable and spotty). In spring feed with sulphate of potash when the new leaves are about 25cm/10in high.

LILIES Lily bulbs have no dormant season. Plant on arrival, preferably in autumn. They are easiest in terracotta pots (one bulb to a 15cm/6in, three to a 25cm/10in pot), which you can fill with a potting mixture to suit the variety, whether the garden soil is acid or alkaline. They will also be very useful garden decoration, as you can move the pots about, and sink them in a border when they're flowering. Use John Innes compost no.2 or no.3, perhaps mixed with leaf-mould and grit, for lilies demand good drainage. Plant with 30cm/12in soil below the bulb so that feeding roots have plenty of space and twice the bulb's depth over its nose. They like plenty of water and good food in the growing season. If picking for the house, cut only halfway down the flower stem so as not to weaken the plant. Move the pot under cover in winter and, if necessary, repot in late winter just before growth starts.

ORCHIDS Most of the exotic types need light, humidity and warmth, but not direct sunlight, not soggy compost, and not a neighbouring radiator. Use porous compost, feel it with the finger before watering; don't let it dry out, but don't water when wet. Stand the pot in a tray of damp gravel; spray regularly with water and feed fortnightly or monthly through the flowering season with half-strength liquid feed. Check recommended night temperatures for individual genera. During the off-season in summer, stand the pot outside in the shade.

POPPIES Choose a dry and sunny site for the perennial oriental poppy (*Papaver orientale*), and one where it will not clash with its

ORCHIDS AND TILLANDSIA (DETAIL), 1993

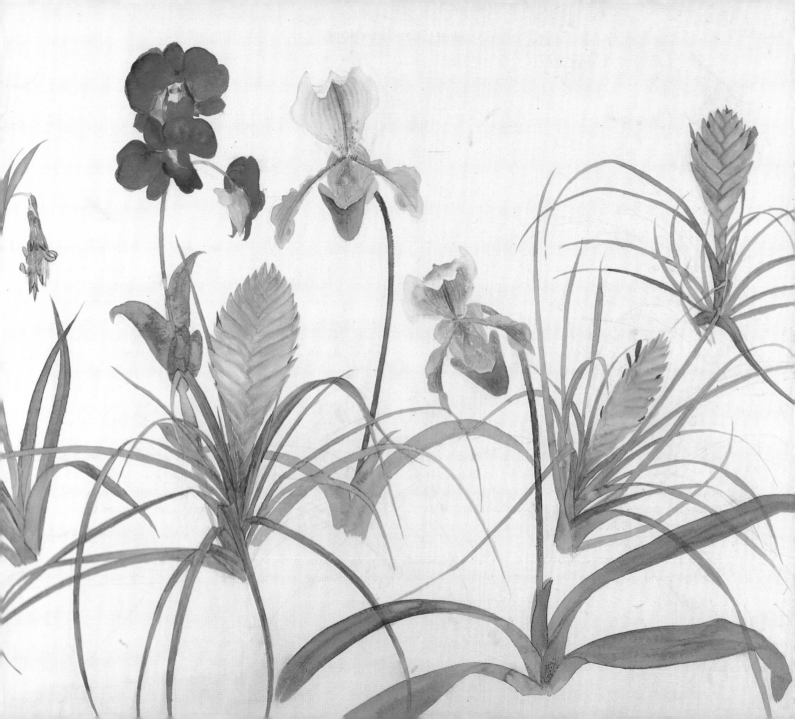

neighbours, as it has extensive roots, and will reappear in the original place even if you try to move it. No rich feeding is needed. Sow annual Shirley poppies in spring, sprinkling the tiny seeds on the surface of raked soil, thin early, and dead-head regularly. Roots of blue Himalayan poppies (*Meconopsis betonicifolia*) must never be allowed to dry out. This enjoys moisture, rich soil and shade. Never long-lived, it may prove biennial, but self-seeds when happy.

STRELITZIA They are garden plants in South Africa, but in temperate climates they need a greenhouse, John Innes compost no.3, a 25–30cm/10–12in pot or, better still, a conservatory bed, for they grow very big. Small plants won't flower for five years, but large plants will produce thirty to forty flowering stems a year. Water them liberally in summer with occasional liquid feed; in winter they can be almost dry, and can readily survive temperatures of 7°C/45°F.

TULIPS Received wisdom says that tulips should be lifted and moved after flowering: at least every three years. In practice they may survive for much longer in one place, provided they have been planted deeply (at least 15cm/6in) and that you remove decaying foliage after flowering. They like good drainage, sunshine, and a sprinkling of sulphate of potash in early spring. You can plant the bulbs as late as the beginning of winter. They perform handsomely in large pots, planted 15cm/6in apart.

WILD FLOWERS Meadow gardening is the fashion, but scattering a tempting packet of mixed wild-flower seed into a lawn seldom succeeds: the seedlings are invariably swamped by more vigorous grasses. It is better to prepare a separate seed-bed, raking well and treading the surface lightly afterwards. Then transplant thriving juvenile plants into their desired positions after the grass has been cut. It will need two cuts a year; one in early summer when the bulbs leaves have died down; the second in late autumn.

INDEX

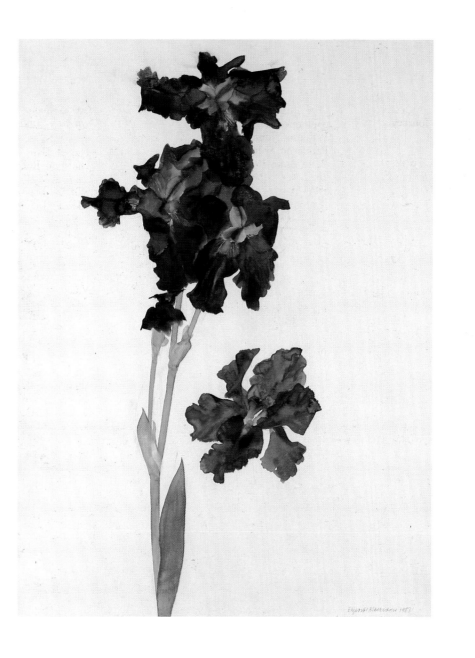